"Going far beyond a simple assessment of Christlike martyr figures (the movies are lousy with 'em), Josh Larsen's passionate and movingly reflective new book makes an inspiring case for treating a provocative variety of films as prayers for all seasons. He writes on everything from Terrence Malick's *The Tree of Life* to Michael Haneke's *Amour*, teasing out the filmmakers' insatiable desire to wrestle with the unknowable. But his democratically theological approach to the medium he loves brings into play unexpected gems: Polanski's *Chinatown*, or Demme's *The Silence of the Lambs* (to which Larsen took his future wife on a date). 'Many films,' he writes, 'even the challenging ones, are capable of functioning as messy, mixed-up, miraculous prayer.' I've long been engaged by Larsen's film criticism on *Filmspotting*, but his book seeks and finds a higher power and a more mysterious set of concerns, somewhere out past the lobby."

Michael Phillips, *Chicago Tribune*

"This is one of the best books on film and theology I've ever read. By conceiving of and engaging with movies as 'prayerful gestures received by God,' Larsen guides the reader in a study that is itself a reverent, prayerful gesture. Packed with insights into how both the content and the form of films can mirror prayer, *Movies Are Prayers* is a must-read for anyone who has ever felt the pangs of transcendence in a movie theater. Yet this is a book as much about prayer as it is about pop culture. Readers will gain not only new language with which to understand movies, but an enlivened paradigm for understanding prayer."

Brett McCracken, film critic for *Christianity Today*, author of *Gray Matters* and *Hipster Christianity*

"There's a lot of writing on film and theology, but a perspective like Larsen's— fresh, insightful, and interesting for anyone—is a rare gift to cinephiles and more casual movie viewers alike. In *Movies Are Prayers*, Larsen encourages us to rethink movies as not just vehicles for content, but as actual expressions of the heart's deepest longings, readjusting the way we think about both films and their creators—and, by extension, ourselves as viewers and critics."

Alissa Wilkinson, film critic, Vox.com, associate professor of English and humanities, The King's College

"With a rich understanding of film history and the Scriptures, Josh Larsen's *Movies Are Prayers* provides a revelatory look at how movies—their messages, their characters, and even the process of making them—can serve as acts of worship. Larsen's readings of films are welcoming, accessible, and insightful. *Movies Are Prayers* will help Christians everywhere look at film in a whole new light."

David Chen, editor-at-large, Slashfilm.com

"I'm about as far removed from religion and spirituality as one could possibly be, and yet *Movies Are Prayers* opened up for me an entirely new way of appreciating the movies I love and the art of filmmaking as a whole. As Larsen points out, it's so easy for even the most obsessive cinephiles among us to fall back on viewing cinema through the cynical lens of commercialization or a frothy lens of mere escapist entertainment. By reexamining an array of movies, including the ostensibly secular (*Trainwreck, The Muppets*), via the language of prayer, this engagement with the medium uncovers a different and fascinating approach to film theory."

Aisha Harris, *Slate* culture writer, editor, and host of the podcast *Represent*

"Larsen pulls on the complexities of the prayerful posture—yearning, lament, confession, joy, and more—that bring us closer to the self as recipient of film than previous comparisons of the movie theater with church and sacred space. Joining the breath of a movie with the breath of prayer, he teaches us anew. This vision of presence and the movements of prayer at the movies are offered through profound films often ignored by the Christian public, making the book a needed addition to the library of the prayerful, reflective, movie-loving Christian."

Rebecca Ver Straten-McSparran, director, L.A. Film Studies Center

"Spoiler alert: Josh Larsen's *Movies Are Prayers* will have you reevaluating your relationship not just to the silver screen, but to story itself. Displaying a prodigious breadth of knowledge and an infectious passion for his subject, Larsen draws an invaluable map of the vast spiritual landscape staked out by cinema while outlining a persuasive, and dare I say exciting, approach to the life of faith—indeed, to life, period. Expansive, gracious, and beautifully written. I'm saying a prayer of grateful awe right now."

David Zahl, editor of *The Mockingbird Blog,* author of *A Mess of Help*

"*Movies Are Prayers* is for the movie lover and the infrequent viewer, the person who prays daily and the one who seldom does. Rather than looking at movies as mere entertainment or a means of teaching moral lessons, Larsen invites us to view the medium as a means of expressing our joy, sorrow, and longings— for a right world, right relationships, and right hearts. In the process, we not only see that movies are prayers, but we see our innate human desire to commune with our Creator."

Erik Parks, filmmaker; **Catherine Parks,** author of *A Christ-Centered Wedding;* cohosts of *The Whole Spectrum* podcast

MOVIES ARE PRAYERS

HOW FILMS VOICE
OUR DEEPEST LONGINGS

JOSH LARSEN
CO-HOST OF *FILMSPOTTING*

FOREWORD BY MATT ZOLLER SEITZ

IVP Books

An imprint of InterVarsity Press
Downers Grove, Illinois

InterVarsity Press
P.O. Box 1400, Downers Grove, IL 60515-1426
ivpress.com
email@ivpress.com

InterVarsity Press® is the book-publishing division of InterVarsity Christian Fellowship/USA®, a movement of students and faculty active on campus at hundreds of universities, colleges, and schools of nursing in the United States of America, and a member movement of the International Fellowship of Evangelical Students. For information about local and regional activities, visit intervarsity.org.

While any stories in this book are true, some names and identifying information may have been changed to protect the privacy of individuals.

Cover design: Faceout Studio
Cover illustration: Kimberly Brock
Interior design: Daniel van Loon

ISBN 978-0-8308-4478-4 (print)
ISBN 978-0-8308-8111-6 (digital)

Printed in the United States of America ♾

Library of Congress Cataloging-in-Publication Data
A catalog record for this book is available from the Library of Congress.

P	20	19	18	17	16	15	14	13	12	11	10	9	8	7	6	5	4	3	2	1
Y	34	33	32	31	30	29	28	27	26	25	24	23	22	21	20	19	18	17		

CONTENTS

FOREWORD

Matt Zoller Seitz

Whenever I speak to groups about movies or criticism, I am invariably asked which critics I think people should be reading. I suggest a few names, often people who write for major publications or online journals of note. But then I tell them that if they're interested in form as well as content, and in the relationship between the two—that is, if they're looking for actual criticism as opposed to reviews, but written in language that can be understood by somebody who didn't go to film school—then they should be reading critics who write for a religious or spiritual audience.

I suggest this not because I am particularly religious myself—though I do believe there's more to life than what we can scientifically quantify—but because there's a disconnect between what marketers have told Christian audiences are Christian films (a narrow slice of mostly bland, ineptly made, and insufferably

preachy bits of "product") and the ones recognized by critics such as Josh Larsen, whose extraordinary book you are about to read. And a critic such as Larsen writes much more perceptively about what a film actually is, what it contains, what it says, and how it says it, than all but a handful of critics who don't carry the difficult responsibilities that spiritually minded critics shoulder every day of the week.

The committed filmgoer who is also a committed Christian occupies a uniquely precarious position within film culture. Much arts criticism is at best coolly secular or indifferent to faith, and at worst actively hostile to most forms of organized religion, as well as to the notion that the experience of the uncanny or inexplicable or intuitive or mysterious might be applicable to daily life as well as to fictions that involve wizards, witches, Jedi, demons, and prophets.

A critic such as Larsen also encounters resistance (and sometimes hostility) from that sector of the audience that is mainly interested in knowing what sorts of films won't offend their faith or their sense of propriety, or force them to explain things to their children that they would rather not have to discuss. To this kind of viewer, who thinks of criticism mainly as a consumer guide, criticism of the kind that Larsen practices so well can only provoke discomfort, or the sort of introspection that leads to discomfort, and who wants to feel uncomfortable?

Caught between the proverbial rock and a hard place, Larsen slips free and embarks on his own journey. Like a pilgrim in a novel or poem from long ago, Larsen doesn't just head directly into the nearest house of worship in the town where he was born and has never left, pick up a prescribed text, and start reciting the old tried and true words, chapter-and-verse. He looks up at the

sky and off toward the trees, not just down at the text. He seeks out life experiences he could never imagine on his own and scrutinizes them with an open mind and an attentive ear. He roams. He's a traveler. A seeker. He is curious and wise, but never self-regarding. He sees faith and finds God in places you might not necessarily expect, and locates lessons—more often questions—in quite a few films that you wouldn't immediately describe as being concerned with such things.

And Larsen never makes the mistake of assuming that because a film contains subject matter that some might consider objectionable, it cannot possibly be of interest to a viewer who cares about spiritual matters. The stories of sinners often have as much to tell us about the human condition as the stories of saints—usually more, because even on our best days, most of us are closer to sinner than saint: a work in progress, doing the best we can to confront the big issues, but often just kind of muddling through, doing the best we can.

And so you'll find *Do the Right Thing* in here, and *Close Encounters of the Third Kind*, and *Avatar*, and *Rushmore*, and *The Life Aquatic with Steve Zissou*, and *Top Hat*, and *A Hard Day's Night*, as well as the filmographies of Hayao Miyazaki and David Lynch, Krzysztof Kieślowski and Martin Scorsese, Terrence Malick and Frank Capra. Larsen writes about love, loss, grief, suffering, and endurance. He writes about ecstasy and abandon, shame and guilt. He finds all of life in movies, even in movies that outwardly seem to have little to do with life as most of us know it, and he connects it back to scripture, to a rich tradition of spiritually inclined literature and visual art, to his own experience, to the history of this country and others, and to faiths besides Christianity. He can read a film as if it were a sacred text or admire it

like a cathedral; other times he seems to have moved into it and lived inside it long enough to absorb its sounds and smells and memorize the way the sunlight hits the bedroom floorboards.

The result is an essential book for anyone who thinks of cinema as a place of introspection as well as escapism, and believes that you can find signs and miracles anywhere if you know how to look for them.

MOVIES ARE PRAYERS?

Movies can be many things: escapist experiences, historical artifacts, business ventures, and artistic expressions, to name a few. I'd like to suggest that they can also be prayers.

What, exactly, is prayer? You already know. You've prayed, even if you haven't set foot in a church for years (or ever). You've longed, you've desired, you've marveled, you've groaned. You've looked around at the beauty of the world, as the Welsh miners do in *How Green Was My Valley*, and said, "Wow." You've seen great suffering, as Sheriff Ed Tom Bell does in *No Country for Old Men*, and asked, "Why?" Who is it that you and the miners are praising? Why are you and the sheriff bothering to complain?

Prayer is a human instinct, an urge that lies deep within us. Religion came along to nurture, codify, and enrich it. Christians look to the Lord's Prayer, given by Jesus, as one model for structuring communication with God (Mt 6:9-13). A testimony of praise and an expression of yearning, a confession of sin and a pledge of obedience, the Lord's Prayer addresses both the nature

of God and our desire to be in relationship with him. It is a beautiful encapsulation of our instinctual desire to seek the divine.

Somewhere early in my childhood, I was taught a similar way to structure my prayers: first give thanks and praise, then pray for others, and only after offering confession should I speak of my own concerns. It is a discipline that has served me well, and a method I still follow—although at the end of these busy, midlife days I often succumb to sleep before I make it to confession. (Convenient, right?) Thankfully, there are other structured prayers in my life. Church liturgy, an art form in itself, gives me words from Scripture when I can't find the right ones on my own. Devotionals encourage a time of patient, quiet, and unhurried contemplation of God's Word. Requests for prayer on social media—some from friends regarding personal concerns, others in response to global tragedy—jostle me out of the self-involved stupor of my daily routine and remind me to lift others to God.

Often, however, my prayers emerge outside of liturgical tradition, church structure, or prompting by other Christians. The prayers I knew first and still know best are guttural. They're wonderings and wanderings prompted by those moments, both sublime and sorrowful, that can't be explained by biological function or natural selection. They're instinctive recognitions of good (of things worthy of praise) and evil (of things inexplicably bent and broken). Whenever I sense something beyond this temporal world—whether the movement of God or the machinations of wickedness—I respond, without formation or premeditation, in awe, anger, or confusion. In these unplanned and impulsive prayers, I'm just a boy standing before God, asking him everything. (Apologies to *Notting Hill*'s Julia Roberts.)

Theophan the Recluse, a nineteenth-century bishop in the Russian Orthodox Church, wrote extensively on the role of prayer in the Christian life. In *Philokalia: The Eastern Christian Spiritual Texts*, Theophan is attributed with this description of prayer: "Prayer is the raising of the mind and heart to God—for praise and thanksgiving and beseeching him for the good things necessary for soul and body."[1] I like this intermingling of the intellectual and emotional elements of prayer, this mixing of the mind and the heart. It recognizes that as much as we try to corral it via rigorous religious tradition (for good and faithful reasons), prayer also takes place beyond the boundary waters, in places and ways we might not expect. This human instinct to reach out in praise or lament or supplication or confession to the divine does not take place only in church, guided by liturgy and pastors. It isn't limited to early morning devotions, in that serene space before silence gives way to the day. It isn't strictly the domain of dinner tables, where families gather to recite familiar words ("God is great, God is good . . ."). And it isn't an instinct shared only by Christians. Prayer can be expressed by anyone and can take place everywhere. Even in movie theaters.

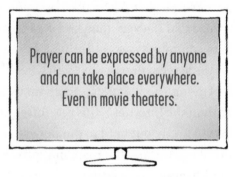

Prayer can be expressed by anyone and can take place everywhere. Even in movie theaters.

MOVIES AS PRAYER

Some of my earliest memories are from sitting in church sanctuaries—hearing Scripture read aloud, having a grandmother

tickle my arm, feeling the rumble of the organ, straining against an itchy shirt collar. Other memories, from nearly as far back, are from sitting in movie theaters (more comfortable collars, less Scripture). I spent many childhood Saturdays with my movie-fan parents at the theater, while the occasional Sunday found me tagging along with my dad to the church where he was serving as the guest preacher. Perhaps it was inevitable that films and faith would become intertwined in my head and my professional practice. As an adult I eventually found myself, on occasion, at worship on a Sunday morning and in study of a film that afternoon, a transition that felt natural and good. In time, I began to recognize that the very things we had been expressing in prayer as a faith community were also, in a less liturgical way, being expressed on the screen. Prayer was everywhere.

Among the countless anonymous spiritual phrases floating around the Internet is this one (often attributed to a man named Edwin Keith, but hard to pin down to a single source): "Prayer is exhaling the spirit of man and inhaling the spirit of God." This book examines the ways movies exhale. Not only *Chariots of Fire* or *Amazing Grace*. I mean movies you wouldn't immediately associate with religious meaning. *Chinatown. Do the Right Thing. The Searchers. Pinocchio. A Hard Day's Night. The Muppets.* (Yes, the ones wearing felt.)

When Spike Lee exhales, we get *Do the Right Thing.* When Roman Polanski and Robert Towne and Jack Nicholson exhale together, we get *Chinatown.* When the Beatles exhale and Richard Lester is there to capture it, we get *A Hard Day's Night.* Each of these films, in their own distinct way, offers a response to the two great existential questions that we ask of God almost every day: What do I make of this place? Why am I here? *Chinatown* answers

with a lament. *A Hard Day's Night* rejoices. *Do the Right Thing* seethes, then unexpectedly reaches for reconciliation. Each offers a prayer.

Of course, none of these movies open with the phrase "Dear God." A fundamental assumption of this book is that prayer can be an unconscious act, one guided by the Holy Spirit as much as our own script (Rom 8:26). For Christians, such impulsive, mysterious prayer is another part of our tradition, one rooted in and directed at the saving God we believe in. We offer quiet, instinctive prayers every day—hopes, worries, and frustrations that never quite take the shape of spoken words or fit into religious routines. Yet those who would not claim Christian identity also make such deeply felt gestures. And we all direct these gestures at an assumed audience outside of ourselves. God may not be the name always given to that unseen listener, but he is nevertheless the one who hears.

In *Prayer: Finding the Heart's True Home*, Richard Foster describes the malleability of prayer: "Countless people, you see, pray far more than they know. Often they have such a 'stained-glass' image of prayer that they fail to recognize what they are experiencing as prayer."[2] Movies offer these sorts of unconscious prayerful gestures, only much louder and on a giant screen. If it helps, imagine stained-glass windows along the walls of a theater. It's no coincidence, after all, that the spaces have similar architecture. The knee-jerk comparison to make is a pejorative one: that both places are designed for worship, the implication being that good people go to church to worship God and bad people go to the movies to worship everything else. There is some truth to this reductive reasoning; certainly the most shallow and exploitative of our movies can direct our desires in self-destructive

ways. But I think a more fundamental commonality between sanctuaries and theaters is the notion of focus. In both instances, we've set aside our time and our space to gather in community and join our concentration. Often the intention is simply to escape the world (and don't forget, church serves this function too), but frequently we gather to apply our intellectual, emotional, and artistic prowess toward considering the world and our purpose within it.

For me, gathering with God's people to hear his Word and sing his praise is a reorienting experience, as if I've been wandering in a wilderness and am suddenly handed a compass. There is a small church in the Roseland neighborhood of Chicago that I sometimes attend, where the sanctuary is a low-ceilinged, windowless space and the attendees range from faithful, multigenerational families in their Sunday best to bedraggled loners who just rolled in after a night on the street. Together, sitting in temporary rows of chairs that leave scuff marks on the tile floor, we read these words projected on a screen:

> As followers of Jesus Christ,
> living in this world—
> which some seek to control,
> and others view with despair—
> we declare with joy and trust:
> Our world belongs to God![3]

With that, a humble space has become holy, and those of us inside it, each lost in our own way, have been found. Can movies offer the same sort of communal, confessional prayer?

The work of Dutch theologian and former prime minister Abraham Kuyper encourages this understanding of the moviegoing

experience. In his 1905 treatise on common grace, newly translated in 2011, Kuyper advanced the idea that God's gifts, including those of artistic talent, are lavished on all of humanity—whether the artists are believers or not, whether they're painting a portrait of Christ or sewing a costume on a Muppet.[4] What's more, the art they each create falls beneath God's sovereignty. Consider Kuyper's most well-known words: "There is not a square inch in the whole domain of our human existence over which Christ, who is Sovereign over all, does not cry: 'Mine!'"[5] As such, reflections of God's grace and his revealing truth can be found in the most unexpected of places. I'd also suggest that our attempts to seek that grace and grasp that truth can take unexpected forms.

Now, it's hard to make the case that Kuyper would have been at home in the modern multiplex. In his treatise he bemoaned that artistic standards were already being eroded at the turn of the nineteenth century, when artists were "no longer following the law of more refined taste but succumbing to lower taste, to say nothing of the false taste of what people identify as popular."[6] Kuyper likely would not have shared my deep affection for *The Lego Movie*.

And yet his theology, if followed to its logical end, opens the door even to broad comedies. Why should God's grace not extend there? If Kuyper had deigned to attend a movie theater, I like to think he would have found common grace—this notion that an agnostic artist, by God's favor, can capture the glory of his creation—flowing from the screen. From the silent melodramas of Kuyper's time to the colorful animated extravaganzas of today, endless creativity is on display in the collaborative work of hundreds of artists: cinematographers, editors, actors, directors, costumers, musicians, production designers, and more.

And when the resulting movies genuinely yearn, mournfully lament, fitfully rage, honestly confess, or joyously celebrate, they serve as prayers.

THE LANGUAGE OF PRAYER

This book identifies nine different expressions of prayer and then places an array of films within each one. Praise, confession, and obedience—the tenets of the Lord's Prayer—are some of the forms I explore. The rich biblical tradition of lament, the mystical practice of Christian meditation, and the more excitable expression of prayerful joy are other areas of focus. Along the way, you may notice that the order of these types of prayer has been arranged to follow the overarching narrative of Scripture: that this world was created good, fell into sin, has been redeemed by Christ's work on the cross, and now awaits the full return to its original glory. Our prayers, both personal and cinematic, always take place somewhere along this creation-fall-redemption-restoration timeline.

I intend for this book to offer two things: a consideration of the role of prayer in the Christian life, and a way of exploring film from a theological perspective. I hope to bring prayer out of the cloisters and into the crud of the everyday, which is where I often engage in it. If prayer is where my thinking about God runs up against my experience of the world, then I will need a way to understand that experience beyond memorized phrases. The poet Christian Wiman touches on this in his meditation/memoir *My Bright Abyss*: "The purpose of theology—the purpose of any thinking about God—is to make the silences clearer and starker to us, to make the unmeaning—by which I mean those aspects of the divine that will not be reduced to human meanings—more irreducible and more terrible, and thus

ultimately more wonderful. This is why art is so often better at theology than theology is."[7]

Such a melding of art and understanding, of film and faith, may make some squeamish, for a variety of reasons. If you come to this book more interested in cinema than theology, be assured I have done my best not to highjack the art, not to bend it to my own purposes so forcibly that it breaks. In hopes

Just as holding a prism against a slit of sunlight reveals a variety of colored beams, this book might help our understanding of both God and the movies to shimmer in a new way.

of preventing that I spend a fair amount of time on *film form*, appreciating the particular choices and techniques of the filmmakers and exploring how those aesthetic elements evoke the action and intention of prayer. As such, these are by no means definitive readings of the movies—the final word in terms of how a film works or what it means. Rather, this is a way of understanding them in light of God's sovereignty, of seeing them as chapters in the larger Christian narrative within which every film's story ultimately takes place.

Theologians may have other concerns. Throughout the book I lean on the work of many different thinkers, yet by no means are the citations meant to be wholly representative of their place within Christian philosophy. No quotation here should be considered definitive. Instead, I mean to use theology as a lens through which to consider these films, and the films as a lens through which to consider theology. Just because Kuyper may not have darkened the door of a movie theater doesn't mean his notion of God's grace can't be brought to bear on the art of film.

My goal, then, is not to be comprehensive but illuminative. In bringing together these two practices—theological reflection and film criticism—I'm engaging in what is perhaps best described as a work of cultural refraction. Just as holding a prism against a slit of sunlight reveals a variety of colored beams, this book might help our understanding of both God and the movies to shimmer in a new way.

HERE BE R-RATED MOVIES

There is, of course, another concern some might express about such a project: that some of the films discussed here are not worthy of Christian consideration because of their content. Why, some might ask, have I not limited my scope to movies that are PG-rated, faith-based, or "safe" in some other way?

In the wake of the culture wars of the 1980s and 1990s, during which a "Christian" understanding of film was often reduced to counting the number of swear words in any given movie, there have been many thoughtful arguments explaining why believers should have a more holistic understanding of cinema. In 2014, then *Christianity Today* film critic Alissa Wilkinson nicely restated the case in an essay titled "Why We Review R-Rated Films," where she offered the following reasons: "Because we want to raise questions, not give answers. Because we want Christians to be some of the most thoughtful conversation partners and culture makers you can find. Because we want to celebrate the excellent and mourn what's bad—even if those two things show up in the same place. And because we want to serve our readers as they love their neighbors."[8]

It's also worth addressing concern over content in relation to the foundational subject of this book: prayer. Our prayers, too,

are imperfect. Some of them might be rated R. They are offered by fallen creatures, so they are by nature fallen as well. Set aside any stained-glass image of prayer and consider how they often look in everyday life. We're distracted when we pray. We pray for the wrong things. We use the wrong words. I—far too often and like the disciples—fall asleep. What we offer are not golden gems of shiny spirituality but messy expressions that reflect the brokenness out of which they're born.

The same can be said of cinema. Movies also represent the efforts of fallen creatures who have imperfections of all kinds, moral and otherwise. And so my aim is not to vet films for a specific audience—that's the death of art—but to celebrate how the best of them try, in the same muddled and contradictory way we do when kneeling by our beds, to say something honest and true. This book is not for Christians who are looking for a safe list of movies to watch. It's a way of considering how many films, even the challenging ones, are capable of functioning as messy, mixed-up, miraculous prayer. God grants us the freedom to watch with grace, as Richard Foster alludes to in *Prayer: Finding the Heart's True Home*: "What I have come to see is that God is big enough to receive us with all our mixture. We do not have to be bright, or pure, or filled with faith, or anything. That is what grace means, and not only are we saved by grace, we live by it as well. And we pray by it."[9]

Let's proceed, then, with exactly this sort of grace. Let's accept that prayers can be unintended and can come from unbelievers, that even the howl of an atheist is directed at the God they don't acknowledge. In this way, we can explore movies anew. Films are not only artistic, business, and entertainment ventures, they are also elemental expressions of the human experience, message

bottles sent in search of Someone who will respond. *Into the Wild* praises God for the world's beauty. *Watchmen* laments its inherently fallen state. *Sunrise* offers a pledge of obedience. *Fight Club* cries out in anger. *2001: A Space Odyssey* and *The Wizard of Oz* artfully plead to know him more. God listens to the whispered utterances of the devotee in the church pew. I believe he listens to *The Muppets* too.

MOVIES AS PRAYERS OF PRAISE

Teeming. That word perfectly describes the planet Pandora, which is at the center of James Cameron's 2009 mega-blockbuster, *Avatar.* Life on this alien world gallops and grows, swoops and streams. Lemur-like creatures with four arms swing among skyscraper-sized trees. Feathery, spiral plants as tall as cars instantly shrink at the slightest touch. Bioluminescent seeds drift in the air and gently settle on branches, looking like landlocked jellyfish. Even the ground is alive; stepping on it emits a pulsing blue glow.

In the NIV translation of the Bible, both Genesis and the Psalms use a variation on the word *teeming* to describe the vast life force of the sea (Gen 1:20-21; Ps 104:25). With an expansive vision and a careful eye for detail, Cameron and his animators capture something of that unbridled vitality in *Avatar.* There is a story—involving conflict between visiting earthlings, who have come to strip the planet of its resources, and the native Na'vi, who live in symbiosis with the environment—but the movie mostly enthralls as an act of imaginative world building.

As it guides us through this strange and wonderful place, *Avatar* heightens the experience with extensive use of 3D. I'm normally not a fan of the technology, but there is no denying its effectiveness here, particularly in conveying a sense of height. This is especially true when we visit one of Pandora's most remarkable locations: a range of floating mountains. A collection of massive islands hovering in the air, each is big enough to contain forests and waterfalls. Even the rapacious earthlings pause in awe at the levitating formations, acknowledging the magnificence with a majestic name: the Hallelujah Mountains. Before the humans despoil, they praise.

MADE TO PRAISE

Praise is our fundamental calling as created beings. As essayist Anne Lamott writes in her book on the three essential prayers, "Awe is why we are here."[1] Describing his relationship with us in Isaiah, God announces, "the people I formed for myself / that they may proclaim my praise" (Is 43:21). The prophet Jeremiah delivers this claim: "'As a belt is bound around the waist, so I bound all the people of Israel and all the people of Judah to me,' declares the LORD, 'to be my people for my renown and praise and honor'" (Jer 13:11). Praise will continue to be our purpose in the new creation, as the adoring litanies in the book of Revelation make clear.

Self-involved creatures that we are, this may at first sound like an obligation or even an eternal curse. Most popular depictions of heaven feature cushy clouds and servile angels in hopes of mitigating this perception and emphasizing our own pleasure and comfort. In the 2013 comedy *This Is the End*, our heroes are rewarded with a private Backstreet Boys reunion concert as they enter the pearly gates. (Backstreet's back, indeed.) If the notion

of eternal life sometimes makes me queasy, it's because I too often imagine it in such limited, human terms. Even listening to my favorite band forever and ever (and no, that's not BSB) sounds more like hell than heaven.

Walter Brueggemann helps us reframe the purpose of praise—both in this life and the next—in *Israel's Praise: Doxology Against Idolatry and Idealogy*: "Praise is not only a human requirement and a human need, it is also a human delight. We have a resilient hunger to move beyond self, to return our energy and worth to the One from whom it has been granted. In our return to that One, we find our deepest joy."[2] True joy, then, is unrelated to our own desires and needs, whatever we selfishly believe those to be. Such wants spring

Prayers of praise relinquish us from the burden of maintaining a false status we don't deserve and can't uphold.

from our sinful nature, the misguided belief that we should not only rule our own personal worlds but also that we're capable of it. The pleasure that comes from that sort of prideful world building is petty and desperately maintained, while the joy that comes from recognizing God's place over all of creation is wide and deep. Prayers of praise relinquish us from the burden of maintaining a false status we don't deserve and can't uphold. Praise rightly reorders the hierarchy of the cosmos, giving honor and glory where it is due. And there is contentment unlike any other in that equilibrium.

The doxologies we repeat from Scripture are appropriate, then, because they both capture what God intends for his people

("It is fitting for the upright to praise him" [Ps 33:1]) and also because they express the enjoyment of doing so ("How good it is to sing praises to our God, / how pleasant and fitting to praise him!" [Ps 147:1]). Brueggemann writes of this with a sense of finality: "Glorification and enjoyment, the first serving God, the second including us, are the final purpose of humanity."[3] This understanding of praise is crucial if we are to broaden the horizons for what prayers of praise can be. If our liturgical recitations of the Psalms become rote, they will have become useless, for then our prayerful praise will have lost its delight. But if they reverberate with intentionality and energy, they will overflow and inform every aspect of our lives. When we see praise this way—as an expression of gratefulness that recaptures our created purpose—we will begin to notice echoes of it everywhere: in our relationships, in our vocations, and in our art.

THE ART OF PRAISE

How, then, can movies function as prayerful praise? In bountiful ways. In fact, if you carry the spirit of the Psalms with you into a theater, you'll see such gratitude everywhere. Hymns may be in short supply, yet all sorts of praise is nonetheless offered up from our movie screens.

Let's return to *Avatar*. Is it too much to suggest that the kind of cinematic world building that takes place in the film recalls the original creation? In his book *Culture Making*, Andy Crouch describes such mimicking behavior as a fundamental aspect of all culture. "Just like the original Creator, we are creators," Crouch writes. "God, of course, began with nothing, whereas we begin with something. But the difference is not as great as you might think."[4]

Some might see this attitude as hubris; after all, *Avatar*'s James Cameron is also the man who declared onstage at the Oscars, after winning the best director award for *Titanic*, "I'm the king of the world!" Yet aren't efforts such as *Avatar*—ambitious attempts at subcreation—also a sideways sort of praise? Imitative flattery, *Avatar* honors what God has made by creating a world of its own, then crafting a story about how best to honor that praiseworthy creation. Coursing through so much of the movie is a prayerful gratitude for natural (well, alien) wonder. Standing underneath a glowing tree whose tendrils resemble an illuminated weeping willow, one of Pandora's native inhabitants explains, "This is a place for prayers to be heard." Indeed, it's a place for praise.

Consider also the delicious genre of foodie movies, ranging from *Babette's Feast* to *Jiro Dreams of Sushi*. These are, on one level, odes of thanks, both for the bounty of the earth and the creativity with which we've cultivated it. (In Crouch's terms: "The egg is good, but the omelet is very good."[5]) Or consider the way films like *A Place in the Sun* and *Giant* seem stunned in the presence of a glamorous icon such as Elizabeth Taylor. We may be tiptoeing toward a form of idolatry here (Taylor, after all, also anchored *Cleopatra*), but surely an honorable appreciation for God-given beauty is also part of the equation. *Fantastic Voyage*, another extravaganza from the 1960s, offers praise for the biological miracle that is our created bodies. There is a high camp factor, as doctors are unconvincingly shrunk to microscopic size and injected into a patient's bloodstream. Yet amid the unintentional laughs is an echo of Psalm 139:14: "I praise you because I am fearfully and wonderfully made."

Among the *Spiritual Exercises* of St. Ignatius, founder of the Jesuits, is an understanding of praise that involves the whole

scope of creation. "Man was created to praise, reverence, and serve God our Lord and in this way to save his soul," Ignatius wrote. "The other things on Earth were created for man's use, to help him reach the end for which he was created."[6] Surely some of these "other things" can be movement, light, color, sound— the building blocks of the cinema (and the main characters of Genesis 1). This is why prayers of praise are delightful. They can be endlessly creative. We do not worship a cruel God who demands quotas of praise in rigidly prescribed formats, as if he is an anal-retentive king and we are his sycophantic courtiers. He wants our praise to be creative, to involve the full richness of the Earth (the Pandora he has made) and to reflect our own ingenuity as created beings. And so the Bible models many forms of prayerful praise, from the lute and harp of the Psalms to the Isaiah-influenced doxologies of the apostle Paul. Likewise, our different church traditions evoke praise in a host of ways. Some of us celebrate with African American gospel music, while others reprise Handel's "Hallelujah Chorus." Some of us find our words of gratitude in the Spirit-led moment, while others are guided by Scripture-derived liturgy. Prayerful praise speaks in many languages because it reflects the great diversity of "all the peoples" (Rom 15:11). On occasion, it speaks in the language of the cinema.

ALL THINGS BRIGHT AND BEAUTIFUL

Like *Avatar*, many of the movies that function as prayerful praise are rooted in thanks for the grandness of creation. *Into the Wild*, Sean Penn's loosest and freest film as a director, has just this sort of gratitude. An adaptation of Jon Krakauer's nonfiction book of the same name, *Into the Wild* dramatizes the life of Christopher

McCandless (Emile Hirsch), a college graduate who dropped everything—his savings, his family, his future—to wander the American wilderness. Along the journey, Penn's camera is agog at the rocks and rivers, forests and streams that the young man surveys. Even when McCandless occasionally encounters evidence of the fall (say, a hippie couple whose relationship is crumbling), he still seems to believe he's found his way back to the Garden of Eden.

This youthful enthusiasm is ultimately proven to be naive, as the movie's third act chronicles McCandless's disastrous decision to proceed into the Alaskan wilderness alone. With its tragic ending, *Into the Wild* ultimately affirms our need for community, as well as the reality that nature can be a brute force. If the movie begins as a prayerful ode to the "fruit of his work" (Ps 104:13), it ends with the cowed awe expressed by Job: "If he holds back the waters, there is drought; / if he lets them loose, they devastate the land" (Job 12:15). There's a poignant irony to the obstruction that prevents McCandless from returning to civilization: a swollen stream.

The book of Job is key to understanding another film of prayerful praise: Terrence Malick's *The Tree of Life*. Indeed, the movie opens with onscreen text from Job 38: 4, 7 (ESV): "Where were you when I laid the foundation of the earth? . . . When the morning stars sang together and all the sons of God shouted for joy?" Although the movie's central narrative involves a stern father (Brad Pitt) and beatific mother (Jessica Chastain) raising their three sons in 1950s suburban Texas, the movie pauses at one point to offer a bravura sixteen-minute nature sequence that visualizes the creation of the universe. This unexpected prayer of praise begins with a soft glow amid the blackness of the cosmos. After a few

moments, it develops into a seeping light. Shapes slowly begin to form (the foundations of the earth) and soon recognizable landscapes emerge: fuming volcanos, rushing waterfalls, fecund forests. I'll never forget sitting in a Chicago screening room for an advance showing of the movie—before anyone knew much of anything about the film—and feeling the shock and wonder of this scene. It was like having Genesis 1 wash over me.

This sequence is *The Tree of Life*'s purest expression of awe at the bounty of creation, yet you'll find similar gestures sprinkled throughout. In one of the recurring images in the film, the camera looks up from the bottom of a sandy canyon, where the cinnamon walls curve in and out in an undulating rhythm, allowing slivers of sunlight to sneak between their waves. This is juxtaposed with a matching shot looking up from the floor of a chapel, whose ceiling is a spiral of stained glass. The windows also filter the sun so that it's as if we're inside the shell of a kaleidoscopic snail. Tellingly, the real-life name of that location is Thanks-Giving Chapel, located in Dallas's Thanks-Giving Square. Such places are holy in that they've been set aside for distinct religious purpose. *The Tree of Life* suggests that an unformed—and unnamed—canyon can be as hallowed a place for praise and prayer.

On a far less sophisticated level than *The Tree of Life*, documentary nature films capture this sort of thankful wonder. Disney has its own production arm for these—Disneynature—and those movies have their value. But to truly be immersed in the natural world, I'd suggest *Microcosmos*, a 1996 documentary from Claude Nuridsany and Marie Pérennou that turns a French meadow into an otherworldly fantasia. Using lenses able to capture insects in incredible detail, as well as

time-lapse photography and slow motion, the filmmakers essentially invert the cosmos: what is grand is forgotten and what is minute becomes grand. This miniature landscape recalls Psalm 96:12-13:

> Let the fields be jubilant, and everything in them;
>> let all the trees of the forest sing for joy.
> Let all creation rejoice before the LORD.

That includes those things with scales that glisten, legs that scuttle, and antennae that unfurl. Praise is the purpose of all creatures, great and small.

NEW WAVE OF PRAISE

The films I've mentioned so far praise God for what he has made. Can movies also offer praise by the very *way* they were made?

Consider the French New Wave, which washed across screens in the late 1950s and early 1960s. Steeped in, but not beholden to, the tidy, traditional filmmaking styles of Europe and America, a number of young filmmakers took apart the finished puzzle that was mid-century cinema and began reassembling it with exuberant abandon.

Take 1960's *Breathless*, for example. Audiences were startled by the film's use of jump cuts, in which a scene is interrupted with an edit, only to be followed by a shot that was almost identical to what had just been on the screen. As Jean-Paul Belmondo and Jean Seberg ride in a convertible, for instance, the camera repeatedly cuts away from Seberg, only to instantly return to her from an imperceptibly different angle. This wasn't amateurish discontinuity. It was artistic invention, in this case to portray the prickly, unsteady, and untethered nature of the characters' relationship. The jump

cuts suggest how "seeing" Seberg could mean many different things at the same time. At first glance, however, it was as if director Jean-Luc Godard had taken the disparate pieces to a conventional romance and put them together in all the wrong ways.

If there is a common feature to most of the films in the French New Wave—a frame that keeps this oddly reconfigured puzzle together—it is playfulness. Recognizing this is key to understanding the movement as a collection of prayers of praise. The French New Wave was not a violent coup, a trampling of cinematic tradition in favor of a completely new regime. It was an artful appreciation as much as it was a revolution. (Call it an evolution.) In reinventing the wheel while using the same parts, these movies are ostensibly giving thanks for what came before. And thankfulness (remember Thanks-Giving Chapel?) is a crucial element of praise.

To be thankful to God—for his love, his Son, and his earthly gifts, including art—is to offer praise.

An 1879 sermon by Charles Spurgeon titled "Prayer Perfumed with Praise" is helpful here. Spurgeon wrote, "The point to which I would draw your attention is this: that whether it be the general prayer or the specific supplication we are to offer either or both 'with thanksgiving.' We are to pray about everything, and with every prayer we must blend our thanksgivings."[7] Our praise, then, is inextricably linked with our thanks. To be thankful to God—for his love, his Son, and his earthly gifts, including art—is to offer praise. Taken as a whole, the French New Wave is an expression of thanks for the gift of cinema itself.

Think of a young child's birthday party or a toddler's reaction on Christmas morning. How do such children give thanks for their gifts? Verbal appreciation usually only comes after a parent's embarrassed prompting (*What do you say?*). But watch what the kids *do* with their toys—they play with them. That's what the filmmakers are doing in the French New Wave, and in so doing express great gratitude. The writers and directors are playing with genre and form. The actors are playing with the idea of performance. The characters are cheeky and un-serious (at least until a flourish of tragedy often sets in during the final act). The filmmakers behind the French New Wave are like the girl who opens her LEGO set on Christmas morning, quickly puts it together according to its instructions, and then really has fun by taking it apart and building something never before seen.

SHEPHERDS QUAKE

Let's stick with the idea of Christmas. If your family is like mine, there are certain movies you return to each year to mark the coming of December 25. Frequently, dinnertime Scripture readings tied to our family Advent calendar are followed by a viewing of, say, *A Charlie Brown Christmas* or *The Snowman*. One of my favorite Christmas movies, however, doesn't make it into the rotation, as it doesn't quite capture holiday cheer in the same manner. This would be 2006's *Children of Men*. Set in a speculative 2027, the movie imagines an Earth plagued by chaos, war, and infertility. No babies have been born in eighteen years. England, the last stable nation on the planet, has become a police state, detaining the flood of refugees reaching its shores and battling militant, refugee-rights groups from within.

In the midst of all this chaos is Theo (Clive Owen), a lapsed activist who has been numbed into a ghostly existence. One day, former his colleagues introduce him to Kee (Clare-Hope Ashitey), a young woman who is secretly, miraculously pregnant. They ask Theo to guide Kee to a refugee camp on the coast, where she will be met by an underground group working on a cure for infertility.

Director Alfonso Cuarón stages a riveting sequence near the end of the film, not long after Kee has given birth to the child. A battle has broken out between British troops and the militants, leaving Kee, Theo, and others trapped in a bombed-out apartment building, caught in the crossfire. When the hidden baby begins crying, the other refugees who are huddled in the hallway all turn to look at Kee, stunned. They haven't heard this sound in nearly twenty years. Theo begins ushering her and the child down the hall toward the stairs, and as Cuarón's camera passes, the refugees hold out their hands, hoping to touch the baby's foot. Bullets continue to fly, but the baby's presence seems to create some sort of protective bubble around Theo, Kee, and the newborn.

On the stairwell they meet three rebel fighters who instinctively point their weapons at Theo, then lower them to look at the baby, confused. They pass by. Next Theo and Kee encounter a pursuing squad of British soldiers, who also freeze at the sound of the baby's cries. Their commander screams "Cease firing!" allowing Theo and Kee to walk out of the front of the building, where an entire battalion of soldiers looks upon them in frozen shock. The soldiers open a path—two of them make the sign of the cross and fall to their knees—and Theo and Kee stumble away. Mary and Joseph have, for the moment, made it out of Bethlehem with the Christ child.

P. D. James, on whose novel the movie is based, was a Christian, and the Christmas parallels to her tale are clear. (If the worshiping refugees are the shepherds, does that make the three rebel fighters on the stairs the wise men?) Yet this moment in *Children of Men* does more than function as a narrative echo of the Nativity. It serves as prayerful praise for the awe-inducing miracle of the incarnation, that moment God arrived on this distraught earth to live as a man. Consider, after all, what greeted Christ's birth: prayers of praise. "Glory to God in the highest heaven," the angels sang (Lk 2:14). The shepherds went about "glorifying and praising God" (Lk 2:20), while the wise men "bowed down and worshiped" (Mt 2:11). They too recognized a newborn child in a barren world—only this Child's presence signified new life for all.

The arrival of Christ is the turning point in God's plan for creation. It at once looks back and forward. And so the adoration of the shepherds is an echo of Psalm 96, which celebrates a savior who comes to judge the earth. The worship of the wise men is a precursor to the book of Revelation, which declares, "Worthy is the Lamb!" (Rev 5:12). No wonder that when the cries of Kee's baby were heard, even the drums of war fell silent, offering a humbled gesture of praise.

SONGS OF THE VALLEY

If *Children of Men* offers a parable of prayer, John Ford's *How Green Was My Valley* lifts up literal prayer, as practiced in a coal-mining village in nineteenth-century Wales. The local preacher (Walter Pidgeon) even delivers a suspect soliloquy on the custom at one point, saying "prayer is only another name for good, clean, direct thinking."

Pidgeon's basso profundo aside, far more stirring to me is the way in which the movie's attitude of prayerful praise is captured in its composition. Ford, one of the great visual composers in all of cinema, often fills the frame with groups of men and women, whether they are workers waiting to enter the mine or villagers jammed into a row house to celebrate a wedding. A common shot in *How Green Was My Valley* features a crowd of some fifty men looking in the direction of the camera, given solidarity by the coal-dusted caps they all wear. The framing casts them as congregants (indeed, there are other group shots in church) so that their gatherings have the tenor of congregational prayer.

This is especially true when singing is involved. Songs accompany almost every occasion in the village, be it a wedding, a wake, or simply the daily walk home from the mines. *How Green Was My Valley* opens with a throng of men singing "Bread of Heaven" as they return to their houses, grateful for good work in this green valley. The movie will go on to depict how brokenness intrudes upon this idyll, as workers' strikes, hunger, loneliness, and death all pervade, until the "was" of the title becomes its defining word. Yet even in the movie's mournful framing device, in which a young man looks back on his childhood in the village and recognizes how life there has been irrevocably changed, *How Green Was My Valley* retains an attitude of prayerful praise. It chooses to find solace in memories, and to express thankfulness for them.

Suffering and praise coexist throughout much of Scripture, perhaps most distinctly in the book of Job. What was Job's response to his first wave of misfortune? "The LORD gave and the LORD has taken away; may the name of the LORD be praised" (Job 1:21). And even after more curses were called

down upon him—after his own skin, to say nothing of his valley, had been ravaged—Job responds to God not with anger but with respectful recognition: "I know that you can do all things; no purpose of yours can be thwarted" (Job 42:2). There is something in the somber praise of Job that hits the same notes as the deep voices in *How Green Was My Valley*, booming the final lines of "Bread of Heaven":

> Songs of praises, songs of praises
> I will ever give to thee.
> I will ever give to thee.[8]

Offering praise no matter the circumstance, the song reverberates throughout the Welsh countryside. It can be heard in the memories of those who once lived there and in every film that pauses in its mournfulness to nevertheless offer a moment of prayerful praise. Listen closely enough and you can even hear this music as far as Pandora, where *Avatar*'s Hallelujah Mountains carry its ring.

MOVIES AS PRAYERS OF YEARNING

Comically crammed into a miniature yellow submersible, the eleven or so passengers peer out the front window as it crawls along the floor of the sea. They are on the hunt. Not for treasure and not for a white whale. They're pursuing a jaguar shark; never mind that in the real world such things don't exist.

This, you see, is the world of Wes Anderson, the writer and director of *Rushmore, The Royal Tenenbaums, Moonrise Kingdom,* and *The Grand Budapest Hotel,* among others. The submarine scene takes place in *The Life Aquatic with Steve Zissou,* Anderson's wryly comic tribute to undersea explorer Jacques Cousteau. The movie is sprinkled with peculiar oddities, including the fact that one crew member, played by Seu Jorge, regularly performs acoustic versions of David Bowie songs in Portuguese. In an exterior shot, the sub is depicted as a miniature model. The fish that swim by are stop-motion puppets, with the delightful awkwardness of grade-school science projects come to life.

Piloting the submarine is Steve Zissou (Bill Murray), a once-famous adventurer who finds himself emotionally adrift. On the down side of his career, threatened with obscurity, he's in desperate need of a compass. For now, Zissou is finding purpose in revenge: he's hoping to find and kill the jaguar shark that ate a crew member on a recent expedition. Will vengeance cure his particularly Andersonian case of existential dread? Or is this, as one character describes it, "an illegal suicide mission led by a selfish maniac"?

Either way, Zissou has located the proximity of the jaguar shark and has brought his entire crew along for the confrontation. He extinguishes the sub's exterior lights and brings it to rest at the bottom of a trench, where they wait. After a moment, a school of glowing pink fish—the sort known to accompany the jaguar shark—swarms past. It must be near. The darkness returns and Zissou leans forward, noticing a small dot of fluorescent yellow off in the distance, slowly swaying back and forth as it draws closer . . .

1-888-PRAYER?

Wouldn't it be nice if our prayers were little spiritual epiphanies, moments of pristine connection and sparkling clarity? Shouldn't prayers be direct lines, with God on the other end awaiting our call as eagerly as the late-night telemarketer who wants to sell us Ginsu knives? Because they're usually not that direct—at least not for me—another type of prayer worth considering are those that yearn. Prayers of listening to repeated rings, with no one picking up. (Of not even getting to voicemail.) Of peering into the deep vastness of the ocean, determined to find something, even though many insist it is not there.

Or maybe we don't even have that much faith. Maybe we're still on shore, with no intention of going into the water. Yet even then, despite ourselves, we yearn. In *Answering God: The Psalms as Tools for Prayer*, Eugene Peterson writes, "Prayer reaches into the unknown for whatever we sense, deep within us, will provide wholeness, or for what we hope, far off, will bring salvation. There is more to being human than simply surviving; there is God (or gods or 'higher powers')—looking for God, pleasing God, getting God's help."[1] Yearning, then, is among the most universal of prayers, an instinct even the resolutely irreligious have.

These are frequently the prayers we don't speak out loud, for they are offered up to a God we're not always sure is listening. We're in the realm of doubt here—scary territory, that of "a wave of the sea, blown and tossed by the wind" (Jas 1:6). As much as yearning prayer can be a form of first contact, a tentative toe in the water, it can also be a last-ditch, after-midnight call. *Dear God, if you don't pick up this time . . .*

Yet as much as I despise my doubt, as much as I hate its existential shudders, I wouldn't trust my faith without it. Inexplicably, few prayers feel as *heard* as my doubting ones. None are more genuinely offered. I come from a Protestant tradition that values knowledge and reason, which I rest on as the foundation for my faith. Yet all of that can feel useless when I'm in a quiet room, devoting myself to prayer and holding little more than hope that God is there. On days like that, it is not apologetics or theology that keeps me in prayer, but the yearning that lies behind all of that good work. Yearning is perhaps our truest testimony, a constant reminder to myself that even if my faith is not something I can blindly accept, neither is it something I can blithely discard.

One of the most doubting testimonials I've come across is *My Bright Abyss*, Christian Wiman's account of his own wondering and yearning while facing life-threatening cancer. Concerning spiritual uncertainty, Wiman wrote this: "Honest doubt, what I would call devotional doubt, is marked, it seems to me, by these qualities: humility, which makes one's attitude impossible to celebrate; insufficiency, which makes it impossible to rest; and mystery, which continues to tug you upward—or at least outward—even in your lowest moments."[2]

To feel that tugging is to yearn. To tug back, even ever so slightly, is to pray.

THE ART OF YEARNING

I'll get back to the movies shortly, but let's first consider a different art form: Rembrandt's *The Return of the Prodigal Son*. The painter's deep shadows dominate, as they often do in his work, except for one notable area: the father from Jesus' parable stands in the center-left of the frame, his face effusively aglow as he rests welcoming hands on his kneeling, repentant son.

In his book *The Return of the Prodigal Son: A Story of Homecoming*, Henri Nouwen wrote that Rembrandt's painting "brought me into touch with something within me that lies far beyond the ups and downs of a busy life, something that represents the ongoing yearning of the human spirit, the yearning for a final return, an unambiguous sense of safety, a lasting home."[3]

It's telling that a gifted and prolific writer such as Nouwen would concede such power to something other than words. Just as Rembrandt's painting spoke for Nouwen, movies can speak for us when we're praising God, when we're lamenting to him, and when we're simply aching to know if he's there.

When we offer a yearning prayer, we're something like Nicodemus, stealing into the dark night to speak to Jesus, seeking illumination on the irresistible mystery that is Christ (Jn 3). When movies spill out from the projection booth into the vastness of a theater, they're venturing into a similar darkness and looking for the same sort of light. They are in search of a reason to say, as Keanu Reeves does in *The Matrix*, "Whoa."

This sort of searching is often the fundamental, motivating principle of science fiction. *Solaris, Close Encounters of the Third Kind*, and countless other interstellar epics ask, "Are you there, God? It's me, humanity." When early humans—say, the prehistoric figures in *2001: A Space Odyssey*—look up at the stars in wonderment, they are, in a sense, praying. The movies brought those stars down to earth and gave our yearning narrative shape. Even a fanciful early effort like Georges Méliès's *A Trip to the Moon*, a silent film from 1902 in which a space capsule full of astronomers lands in the eye of the Man on the Moon, implies the most fundamental of questions: Is there something or someone beyond our earthly existence who can satisfy our seeking souls?

YEARNING FOR GOD IN ALL THE WRONG PLACES

There are times when our yearning prayers are so urgent that they lead us in the wrong direction. Such is the case in 1939's *The Wizard of Oz*. Surreal and sneaky, this is a movie of false gods—of men behind curtains—and the persistent desire to believe in them.

Consider the picture's three not-so-wise men: the Scarecrow, the Tin Man, and the Cowardly Lion. Despite their fantastical appearances—Scarecrow's sprouts of stuffing, Tin Man's silver

skin, Lion's cascading curls—there is something familiar about their fumbling and bumbling. And sure enough, once they join arms with Dorothy (Judy Garland) and go skipping down the yellow brick road, we realize: the same actors (Ray Bolger, Jack Haley, Bert Lahr) play Dorothy's farmhand friends back in Kansas. These are dopes dressed as deities, conjured by Dorothy to meet her need for companionship.

Dorothy, you see, is a seeker. Even before the tornado hits, she's in search of guidance and direction, taking advice from the crystal ball of a fortune teller (Frank Morgan). The film's iconic tornado is an extension of her inner turmoil, from the first black tendril that touches Kansas soil to the unnervingly comic sight of Dorothy's neighbor (Margaret Hamilton) pedaling her bicycle in the eye of the storm. When Dorothy survives her dizzying bout of doubt and lands in Oz, crushing the Wicked Witch of the East, the tables are turned. A glowing, Technicolor orb floats toward her until it takes the form of the good witch Glinda (Billie Burke), who mistakes Dorothy for a deity. Likewise, the Munchkins worship her for saving them from the Wicked Witch of the East. Everything's gone topsy-turvy in this wonderfully odd world, except for one consistent element: Dorothy's eagerness to believe.

The Wizard of Oz, then, charts a spiritual journey of wrong paths and continued persistence. Dorothy is eager to believe in a wizard who will grant her wishes, who rules over a "place where there isn't any trouble," to use her own words. Scoff at her naiveté if you will, but I know I've placed my faith in sillier things (comfort, say, or acclaim). It often isn't until such false gods are unmasked that we recognize where our true allegiance should be. This is what happens to Dorothy, whose faith in Oz is not rewarded. She may defeat the Wicked Witch of the

West (Hamilton again, in another of the movie's double roles), but like that witch, Dorothy's hopes melt in the fizz of dry ice. Returning to the Emerald City with the witch's broomstick as a trophy, Dorothy and friends discover Oz is all shadow, all fog—a sham.

The very name Oz has become cultural shorthand for figureheads who only claim to be "great and powerful." A bulbous, floating green head with a booming voice, Oz has all the presence of a true god— until the inquisitive Toto reveals Oz to be made of little more than smoke and mirrors, operated by the familiar Frank Morgan. One of my favorite details in the film takes place

It wasn't Dorothy's accomplishments that mattered but her yearning. If only she had realized earlier that the God she sought was so near.

after Oz has been exposed. Even as Dorothy and friends stare at him in accusation, he continues to frantically crank the gears and levers that operate the Oz show. In denial that his ruse has been uncovered, he seems to think everyone will forget what they're seeing if he can only get the curtain closed again.

How, then, does Dorothy get home? By not trying to earn her ticket. If *The Wizard of Oz* functions as the yearning prayer of a seeker, it also ends as a parable of grace. In the finale, Dorothy comes to realize that "my heart's desire" is in "my own backyard." And with the gentle guidance of the graceful Glinda, she clicks her heels. It wasn't Dorothy's accomplishments that mattered but her yearning. If only she had realized earlier that the God she sought was so near.

LOST IN SPACE

While living for a brief time in Los Angeles, I had the chance to see Stanley Kubrick's *2001: A Space Odyssey* at the Cinerama Dome, an iconic movie theater with a giant, deeply curved screen and loge seating. Something about that venue emphasized how much watching a film—entering into it—requires a posture of prayer. Sitting in our staggered and elevated rows, peering into the inverse curve of the screen, we joined Kubrick's characters not in worship of the iconic black monolith that mysteriously appears throughout the film, but in offering up humankind's strongest longings: How did we get here? Where are we going? What is it that we feel, deep in our bones, calling our name?

Consider *2001*'s iconic, climactic "star gate" sequence, in which astronaut Dave Bowman (Keir Dullea) follows the monolith on a psychedelic journey across space and time. The cliché is to say that you haven't really experienced *2001* unless you've seen it while under the influence of psychedelic drugs, but the Cinerama Dome worked just fine for me. As the movie's horrific, choral howl crescendos in the background, streaks of color rush past us, so that we feel as if we're reaching ever deeper into the void. The colors coalesce, the orientation of the screen flips, familiar shapes begin to form and you realize what is most unnerving about this cinematic depiction of existential yearning: it may actually deliver what we're looking for.

Some of our most ambitious directors have tried to measure themselves against *2001*'s signature sequence, sending their own, wildly cinematic prayers out into the void. Andrei Tarkovsky dispatches Donatas Banionis to commune with a sentient alien ocean in *Solaris*. Robert Zemeckis drops Jodie Foster through an interdimensional tunnel in *Contact*. Darren Aronofsky encases

Hugh Jackman in a star-bound biosphere in *The Fountain*. Christopher Nolan punts Matthew McConaughey into a black hole in *Interstellar*. These are all seekers like Dorothy, only with spaceships instead of ruby slippers.

To this list we could add Roy Neary (Richard Dreyfuss), the central figure in Steven Spielberg's *Close Encounters of the Third Kind*. An easily distracted family man who works for an electrical utility, Roy's brush with the intergalactic takes place somewhere fairly mundane: Indiana. Responding to a power outage one night, he stops his truck near a railroad crossing to consult a map. The silent night is interrupted when, just outside his window, a row of mailboxes begins to move, seemingly of its own accord. The truck's power cuts out, silencing the radio and leaving Roy in darkness. Suddenly a glare of light beams down from above. Gravity is altered, as items fly about in his cab; the radio audio returns, but scrambled into nonsense. And the railroad crossing sign rattles back and forth maniacally, matching the panicked beat of Roy's heart. Then things calm, the sounds quiet and Spielberg's camera moves in on Roy's face, the face of a man who has looked into the void and lived.

This is, indeed, Roy's conversion experience; only he isn't quite sure yet what it is he's supposed to believe. And so he goes on a yearning journey, guided by his UFO encounter and a recurring vision he has of a strange, flat-topped mountain. Roy is nothing if not an impassioned seeker—akin to the psalmist whose "soul yearns, even faints, for the courts of the LORD" (Ps 84:2)—to the point that he begins making sculptures of the mountain with mashed potatoes at dinnertime, offering them as some sort of prayerful gesture. There is comedy but also tragedy here, as Roy's obsession becomes so all-encompassing that he's eventually

willing to leave his young family behind in pursuit of what he does not yet fully understand.

You can read *Close Encounters*'s climax—a bravura light show in which Roy climbs that mountain and reconnects with the aliens in an ecstatic manner—in a variety of ways. It is, to be sure, a moment of familial abandonment. (Spielberg's parents divorced when he was a teenager, and broken families are a common theme in his films.) Yet it is also one of religious devotion, perhaps something like James and John leaving their father behind to follow Jesus (Mt 4:18-22). More than anything else, though, *Close Encounters of the Third Kind* is our everyday yearning writ large, a story of one man's single-minded attempt to reach out to the mysterious presence that has called his name. To pray.

PRAYER AS PINING

There is another obvious but perhaps uncomfortable way in which movies echo the act of yearning prayer: romantically. We may hesitate to see the throbbing desire of cinematic lovers as a metaphor for our craving of relationship with God, but remember that even Jesus compared himself to a bridegroom and the church to his bride (Mt 25:1-13).

If reading an impassioned, physically explicit romantic drama this way seems a bit much—if it literalizes Scripture too coarsely or spiritualizes carnality too casually—let's instead consider a subgenre that perhaps better captures the nature of yearning prayer: movies of unrequited love. I'm thinking of *Casablanca*'s Rick (Humphrey Bogart) telling Ilsa (Ingrid Bergman), "You're getting on that plane . . . where you belong," despite their burning to be together. Or the apartment neighbors (Tony Leung and Maggie Cheung) in Wong Kar-wai's *In the Mood for Love*, who discover

their respective spouses are having an affair but refuse to exploit their own intense attraction for revenge. The yearning in these films is earthly yet also spiritual; it's an expressed prayer for the right relationship with God that often feels just beyond our grasp.

An especially intense sort of existential longing can be felt in the films of Alain Resnais, particularly *Hiroshima Mon Amour* and *Last Year at Marienbad*, his back-to-back contributions to the French New Wave. In both pictures a couple agonizes over the tenuousness of their respective relationship, even as the structure of the films—abstract imagery, seemingly arbitrary voiceovers, nonlinear plotting—echoes the spiritual disconnection that the characters feel.

Last Year at Marienbad is more of an intellectual puzzle movie (at a lavish hotel, a man tries to convince a woman that they met there a year before), but in *Hiroshima Mon Amour* the romantic angst feels achingly real. Here, a French actress on location (Emmanuelle Riva) has a brief affair with a Japanese architect (Eiji Okada). It is a moment of searching connection that leaves them both deeply shaken, in part because its crosscultural nature resurfaces memories of the catastrophic ending to World War II. The movie's opening shot is of the lovers' limbs entwined and coated with a dust that is lightly falling from above. The image dissolves into a more familiar one, of the same limbs glistening with sweat, but the implication is clear: the couple's present-tense embrace is haunted by the literal fallout of human brokenness.

The actress's leap into the architect's arms is meant to be a buffer against such despair—a way of using momentary pleasure to assuage her persistent unease—yet the irony is that their togetherness only increases their sense of dissociation. Like so many movies about doomed love affairs, *Hiroshima Mon Amour*

accounts for the limited satisfaction that human relationship provides in this dis-eased world. Our fumbling attempts at connection are fleetingly fulfilling simulacrums of the restored re-

Our fumbling attempts at connection are fleetingly fulfilling simulacrums of the restored relationship we seek with God.

lationship we seek with God. This is why even in "right relationships," we still yearn.

With this in mind, it makes sense to find romantic resonance in Scripture passages such as Psalm 42:1: "As the deer pants for streams of water, / so my soul pants for you, my God." Relief from exhaustion is the primary metaphor at work here, yet there is also an allusion to desire. (Psalm 63:1—"my whole being longs for you"—works similarly.) If we're tentative about comparing our yearning prayers for God to our romantic yearning for others, this is because we're working the metaphor backwards. It isn't that true communion with God resembles the physical closeness of a lover; it's that divine communion is so incomprehensibly fulfilling—and so presently out of our grasp—that we must use a variety of earthly experiences to even come close to understanding it. One way of bridging that gap is to evoke the experience of unrequited love.

PLAYING CHESS WITH DEATH

If it seems like a long way from *Hiroshima Mon Amour* to Psalm 42, here is a shorter journey along a more clearly lined path. Ingmar Bergman's *The Seventh Seal*, one of the most famous

religious allegories in movie history, is yet another model of yearning prayer: that of the faltering believer.

The Seventh Seal confesses that even if our searching has led us to God, there are times when we cannot feel his presence. And so yearning continues all our life, especially when we face confusion or turmoil. In the film a knight comes back from the Crusades in need of conversion. Sent as a fervent believer, he returns in anger and doubt. Death approaches in the form of pale, black-eyed being (Bengt Ekerot) beneath a dark hood, and the knight holds him off by proposing a game of chess. Before he dies, he needs to know for certain that God exists.

Max von Sydow plays the knight Antonius Block with a noble panic in his eyes. "I want knowledge!" he demands. "Not faith, not assumptions, but knowledge. I want God to stretch out his hand, uncover his face and speak to me." A medieval Habakkuk, Block's demand is similar to the Old Testament prophet's challenge: "How long, Lord, must I call for help, / but you do not listen?" (Hab 1:2).

The Seventh Seal depicts the lengths to which Block is willing to go to receive an answer. Encountering a girl who has been accused of being a witch, he asks for an introduction to the devil. Why? she wonders. Because if anyone knows about God, it's him.

Set in the midst of an awful plague, *The Seventh Seal* paints the anguish of spiritual uncertainty with barbaric brush strokes. During Block's travels, he encounters people desperately attempting to appease an uncommunicative God. Blaming the accused witch for the plague, soldiers burn her at the stake. (Looking into the girl's eyes during her final moments, Block sees not the devil but "emptiness.") A parade of flagellants passes, beating themselves and others in hopes of ridding the land of sin first, disease second.

And yet the most palpable despair in the picture is Block's. "Why can't I kill God in me?" he asks. "Why does he live on in me in a humiliating way—despite my wanting to evict him from my heart? Why is he, despite all, a mocking reality I can't be rid of?"

You could argue these are the same questions Bergman asked his entire career. The son of a strict Lutheran pastor, Bergman's biography almost always includes a reference to being enclosed in a small, dark space as a form of childhood punishment. Perhaps that accounts for the stark harshness of his work. Grown and given creative freedom, the Swedish dramatist began loudly challenging God (*The Seventh Seal*, *Through a Glass Darkly*, *Winter Light*), grew more subtle in his questioning (*Persona*, *Cries and Whispers*), and eventually subsumed his spiritual quest in domestic or autobiographical efforts (*Scenes from a Marriage*, *Fanny and Alexander*). His films are often those of an aspiring atheist, someone who feels life would be easier without God, yet still can't convince himself that God doesn't exist.

FACE TO FACE WITH THE JAGUAR SHARK

Back at the bottom of the sea, Steve Zissou finds what Antonius Block is looking for. The small, swaying dot of fluorescent yellow grows larger, until it takes the form of a massive, spotted shark— the jaguar shark. The jaws open, revealing rows of teeth. Yet just as it seems about to gobble up the submarine, the creature veers up and slides overhead, leaving Zissou and his passengers in a collective shudder. Expressions of wonder abound, but especially for Zissou. It's as if he's seen the face of God.

The Life Aquatic of Steve Zissou turns, as so many Wes Anderson movies do, on a moment of idiosyncratic epiphany. What Zissou has long sought is found, and found to be far more terrible

and mysterious and merciful than could have ever been believed. "Do you still want to blow him up?" Zissou is asked. "No," he replies. "We're out of dynamite anyway." Someone else says, "It is beautiful, Steve." He responds, "Yeah, it's pretty good isn't it. I wonder if it remembers me."

As Zissou squinches his face to keep back a tear, one of the passengers rests a hand on his arm. Then someone else touches his shoulder. Soon everyone in the cramped sub has leaned forward to lay a hand on him, adopting a posture that recalls that of the father in Rembrandt's *The Return of the Prodigal Son*. The lost explorer has returned home. His yearning prayer has been answered. Meaning has been found.

MOVIES AS PRAYERS OF LAMENT

The man stands at the edge of a patch of graves, a fenced-in area no bigger than a backyard garden plot. Solomon Northup (Chiwetel Ejiofor), the central figure in *12 Years a Slave*, has endured months of forced labor in 1850s Louisiana after being kidnapped in the North. A fellow slave, Uncle Abram (Dwight Henry), has suddenly died in the fields from exhaustion, so Solomon and others are gathered to bury him. The scene opens with an older woman leading them in a Negro spiritual called "Roll Jordan Roll." Solomon, however, stands against the rickety stick fence of the cemetery in dazed silence. Fretful and furrowed, he wears the face of lament.

12 Years a Slave was released in 2013 and went on to win three Oscars, including Best Picture. Watching it is a wrenching experience, as the movie functions as a viscerally cinematic prayer of lament. Director Steve McQueen puts audio and imagery at the forefront, so that even the sound design drips with sorrow. When Solomon is tied by his neck to a low tree branch as punishment,

his agony is captured not only in picture—a dispassionate wide shot of Solomon left alone—but also by the sound of his toes squelching in the mud, despairingly trying to gain solid footing.

One of the defining characteristics of *12 Years a Slave* is the way McQueen occasionally instructs his actors to face us, the audience. The movie opens with a remarkable shot, notable both for its composition and the length for which it's held: a group of slaves stand in a field, bedraggled but resolute, their gaze directed our way, just to the left of the camera. This implicates the viewer, disallowing passive observation, while also suggesting the manner in which *12 Years a Slave* operates as prayer. If the movie camera is often considered to be omnipotent (the "God's eye view" is a standard shot), then looking toward the camera can be equated with staring down God. Even as the movie's slaves are looking toward us, they are looking toward him.

FROM NEGRO SPIRITUALS TO THE PSALMS

Trace the line from the Negro spirituals of the American South back far enough and you'll eventually get to the prophecy and poetry of lament in the Old Testament. Both are the moaning, groaning songs of a downtrodden and exiled people, directed at the God they tenuously claim. The connection is literal, in many cases: "Swing Low, Sweet Chariot" takes its inspiration from the prophet Elijah, who once found his situation so lamentable that he asked to die (1 Kings 19). Yet the stronger tie is theological. W. E. B. Du Bois, whose personal faith has long been a matter of debate, devoted a chapter of *The Souls of Black Folk* to "The Sorrow Songs," in which he described spirituals as "the music of an unhappy people, of the children of disappointment; they tell

of death and suffering and unvoiced longing toward a truer world, of misty wanderings and hidden ways."[1]

And so lament, whatever form it takes, is at heart a prayer, an expression of despair *in hope of being heard.* It is a song sung by slaves at a graveside. It is David's complaint in Psalm 13: "How long?" It is Jeremiah, while announcing God's terrible judgment on his people, also mourning the very suffering that judgment would entail (Jer 14:7-9). And it is Jesus quoting a psalm of lament from the cross (Mt 27:46). These are guttural cries cast from the grime of earth to the ear of God.

Lest you fear that this chapter will be relentlessly bleak, keep in mind that Christian lament is not simply complaint. Yes, it stares clear-eyed at awfulness and even wonders if God has gone. We will spend some time with films that pray in this way. Yet at its fullest, biblical lament expresses sorrow over losing a world that was once good alongside a belief that it can be made good again (Du Bois's "truer world"). Lament isn't giving up, it's giving over. When we lift up our sorrow and our pain, we turn it over to the only one who can meet it: our God.

THE ART OF LAMENT

All of us have known or will know great suffering. If biblical lament ends in hope, then, it's not a hope easily found but rather a tiny needle that has been hidden in haystacks of pain. In his open wound of a book, *Lament for a Son*, Nicholas Wolterstorff grieves the sudden death, in a mountain-climbing accident, of his twenty-five-year-old child. In the aftermath Wolterstorff describes his desire to find something that felt in tune with both his own mourning and the collective mourning of our fallen world.

I tried to jog and could not. It was too life-affirming. I rode along with friends to go swimming and found myself paralyzed. I tried music. But why is this music all so affirmative? Has it always been like that? Perhaps then a requiem, that glorious *German Requiem* of Brahms. I have to turn it off. There's too little brokenness in it. . . . Is there no music that *fits* our brokenness? The music that speaks *about* our brokenness is not itself broken. Is there no broken music?[2]

I'd suggest that there is such "broken" music—if not Brahms, perhaps Nine Inch Nails—and that there are similarly broken films. Often, you can see it right there in the movie's title. *Requiem for a Dream*, Darren Aronofsky's fever dream about drug addiction, chronicles desperation and depravity not to revel in it, as exploitation films do, but to mourn. It's a difficult watch, to say the least. Before I joined the *Filmspotting* podcast, then co-hosts Adam Kempenaar and Sam Van Hallgren came up with a phrase for films that you can't imagine sitting through again, even if you might have greatly appreciated their artistry. They called these movies "one-timers," and *Requiem* was on that list. The movie's main characters are Harry (Jared Leto), the heroin addict who loses his arm to an infection from injections; Marion (Jennifer Connelly), his girlfriend, who endures increasing levels of sexual degradation to achieve her next score; and Tyrone (Marlon Wayans), their friend, who faces imprisonment. Each of them—as well as Harry's mother (Ellen Burstyn), who is enslaved to weight-loss pills—are beyond human help. This is the sort of suffering that must be brought before God.

How do we do that? How can we lament to God? I come from a fairly staid worship tradition, that of a Dutch Reformed heritage. The prayerful postures I'm familiar and comfortable with are, shall we say, discreet. My clasped hands—or even, on rare brave days,

my upturned palms—hardly capture the mournfulness I feel inside. I sometimes wonder, then, if the movies might be my surrogates for actual wailing and gnashing of teeth. When I watch *Requiem for a Dream* or *12 Years a Slave*, the terrible realities of those worlds intermingle with the terrible realities of mine (even if mine might be of an entirely different nature). I can offer lament to God, and often do. But sometimes the movies do it for me.

THE DAY THE SUPERHERO DIED

In recent years, our cinematic prayers of lament have been dressed in curious costumes—superhero costumes, to be exact. We're weary of it now, with the dim brutalism of *Batman v Superman: Dawn of Justice* and *Suicide Squad* fairly fresh in our minds. Yet when comic-book films first took a turn into darkness in the mid-

I can offer lament to God, and often do. But sometimes the movies do it for me.

2000s, they functioned as potent prayers of lament. The brooding Batman had not yet become a cliché.

Consider *The Dark Knight*, from 2008, which explored the dankest recesses of its villain's mind: Heath Ledger's Joker. "Some men just want to watch the world burn," says Bruce Wayne's butler (Michael Caine) of the movie's demonic antagonist. Batman (Christian Bale) is nearly helpless in the face of this nihilism. The fact that director Christopher Nolan never explains the source of Joker's demented worldview makes it all the more potent. Seemingly broken from birth, this is the mind

of original sin, visually represented by the crusty clown makeup that stubbornly clings to Ledger's face like cracked mud.

A box-office behemoth, *The Dark Knight*—along with its 2005 predecessor, *Batman Begins*—nudged the superhero genre in doleful directions, paving the way for perhaps the grimmest costume drama of them all: 2009's *Watchmen*. Director Zack Snyder would go on to overindulge in dreariness with *Man of Steel* and *Batman v Superman*, yet this adaptation of the 1986 graphic novel evokes a true sense of lament. *Watchmen* takes place in an alternate 1980s America, where Richard Nixon is still president; the country is on the brink of nuclear war with Russia; and superheroes, once crucial allies of the law, have been banned as dangerous vigilantes. For someone like me, who used to cheerfully bound across furniture as a little boy in Spider-Man Underoos, *Watchmen* painted a very different comic-book landscape, one that matched my grownup understanding of sorrow more than my childhood experience of free-spirited play.

A sense of doom pervades *Watchmen*, and not only because the camera regularly cuts to an image of the Doomsday Clock, a supposedly scientific measurement of the countdown to inevitable nuclear annihilation. Most of the forcibly retired heroes mope around under a boozy gloom of resignation. This is a severely bent world, and even the costumed crusaders, depicted as egotists, sociopaths, or masochists, are unable to straighten it.

One of these figures is Rorschach (Jackie Earle Haley), a justice-obsessed killer whose mask is a constantly changing map of ink blots. His face reads the true desires of this world and finds the world wanting. Rorschach keeps a journal of bitter rantings that sound like op-ed pieces written by a misguided prophet. "There is good and evil," Rorschach says, "and evil must be punished." His

lamenting too eagerly slips into a thirst for God's righteous anger and eventually seems to even give up on divine justice. "If God saw what any of us did that night, he didn't seem to mind," Rorschach says after he brutally kills a child murderer instead of bringing him in to the police. Notice the "ifs" and "seems" there. This is a tentative prayer of despair, a bitter declaration that stops just short of saying that God too is dead.

Is any of this sounding like 1978's *Superman*, with its cheery primary colors and the hero's curlicue of hopefulness right there on his forehead? *Superman* is a paean to the *imago Dei*—the reflection of God in all humankind—if not a clunky image of Christ. The gist of *Watchmen* is that superheroes can't save us and that some of them don't even want to. If something such as Spider-Man once captured my childlike joy, *Watchmen* is that joy warped by adult experience. I'd heard of pain as a kid; as an adult I've come to know it. And if my pain doesn't always look like the world of *Watchmen*, the movie's palpable despair certainly *feels* familiar. It feels to me like lament.

SOUNDS OF LAMENT, FROM TOKYO TO CHINATOWN

We've considered what lament looks like (Rorschach's roiling mask), but what does it sound like? What movie captures the audible qualities of wailing and gnashing teeth? Let's listen to *Godzilla* (1954).

Specifically, I want to listen to *Godzilla*'s roar: a high-pitched, echoing screech that travels across the waters of Japan like the wind of a tsunami. Yes, compared to our modern audio effects, the noise may sound as if it is coming through a tin can and a string. Yet, as with the visuals in this sixty-plus-year-old monster movie, there is potency to such simplicity. If you listen closely to Godzilla's

roar, you'll notice that it's actually a wail of sorrow more than a threatening bellow. The giant beast isn't terrorizing; it's crying.

This fits, for *Godzilla* is a metaphor for the nuclear destruction of Hiroshima and Nagasaki at the end of World War II, as well as a prediction of the inevitable self-destruction of humankind. This is end of the world stuff, a creature-feature elegy. The pounding on the soundtrack that accompanies Godzilla's footsteps might as well be the ticking of *Watchmen*'s Doomsday Clock. "What brought this upon us?" asks Emiko Yamane (Momoko Kōchi), daughter of the famous scientist who is studying the monster. *Godzilla* goes on to reveal that the beast was awakened by undersea nuclear testing. Oozing radioactivity—its footprints are instant hot zones, its misshapen lumpiness makes the creature look like an atomic burn victim—Godzilla is a two-hundred-foot-tall chicken coming home to roost.

If you've only seen bits of *Godzilla* on television, you owe it to yourself to track down the original 1954 Japanese version, with the title of *Gojira* (and none of the Raymond Burr). The additional forty minutes of footage allow director Ishirō Honda to linger over scenes of despair. In stark black and white, with the camera tracking along lines of wounded and weary citizens, these images are obvious stand-ins for the devastation of Hiroshima and Nagasaki. Yet they also make clear what the film ultimately is lamenting: our seemingly unalterable desire to unleash godzillas upon ourselves.

Like *Godzilla*, *Chinatown* offers literal sounds of lament. In fact, the movie begins with a pair of moans. There is Jerry Goldsmith's score over the opening credits—plaintive, sorrowful, tentatively searching for mercy whenever the tempo picks up. This is joined by the whimpering and eventual wailing of Curly

(Burt Young), a cuckold obsessively paging through photographic evidence of his wife's faithlessness.

Curly is a client of Jake Gittes (Jack Nicholson), a former beat cop once assigned to the shady streets of Chinatown. So disenchanted with the crime and corruption that he witnessed as a cop, Gittes has cocooned himself in private-detective work, where a paycheck (not justice) is the goal. He fully knows of the world's depravity—he spent his time on the force doing "as little as possible," and he's convinced himself that it no longer bothers him. He's given up on a larger, societal sense of justice and is content to deal with the personal corruption of infidelity.

So what draws him back in? *Chinatown* goes on to unspool a web of intrigue involving water rights, city politics, and murder in 1930s Los Angeles. Gittes finds himself in the middle of it all because one of his adultery cases leads to a hint of a larger, citywide conspiracy. When Gittes thinks he's figured it out, he gets a taste of possible redemption, not only for himself but for the idea of justice he once upheld. Yet the conspiracy proves to be knottier than he could have imagined. Gittes suffers a second loss of innocence, one that eventually brings him to his knees.

Lamenting movies are full of figures who have hit rock bottom—the Jake Gittes of the world. They're the ones, as Claus Westermann writes in *The Psalms: Structure, Content, and Message*, who "speak when they can no longer endure continuing pain, pressure, and the absence of prospects for improvement."[3] And so they and their movies lament to God, praying that he doesn't shrug his shoulders and say, "Forget it Jake. It's Chinatown."

Anyone who has seen *Chinatown* knows how misguided and doomed Gittes is. This is more than a noir with flawed, ill-fated characters; this is a depiction of total depravity as theologian

John Calvin understood it. (Robert Towne is the author of the intricate, clockwork-like screenplay, but Calvin could have had a hand in it.) Calvin held that humanity is hopeless and depraved without the grace of God. In Chinatown—and *Chinatown*—there is no God, only sin.

Consider the character of Noah Cross (John Huston), father (and worse) of Evelyn Mulwray (Faye Dunaway) and the likely chief conspirator behind the water scandal. Huston, a legendary Hollywood director/actor at the service here of Roman Polanski, comes across as an evil, nearly inhuman blob: large, deep, and enveloping. His depravity is all-encompassing. He's the fount of all the story's sins, both intimate and corporate. As Cross explains to Gittes, in that horrible, authoritative bass, "Most people don't have to face the fact that in the right time and the right place, they're capable of anything."

Close watchers of *Chinatown* must face that reality, because it is the essence of the picture. After the supremely tragic climax, Gittes's partner famously tells him to brush off the pain and forget what has happened, to go back to his hardened, hopeless shell. *Chinatown* doesn't end. It gives up.

NOWHERE ELSE TO TURN

Not every movie of lament gives up. In fact, it's when they don't that they often manage to evoke a deeper sense of prayerful lament. Beyond depicting despair, these movies seek solace from it. And so they bring their sorrow before God.

This trajectory, common to the Psalms, remains a model for modern worship services. In the June 1997 issue of *Reformed Worship*, John D. Witvliet describes liturgical lament for use in church, modeled on the "basic psalm forms." He writes that

despite our disillusionment, no matter that we cannot hear God's voice, "we bring our most intense theological questions right into the sanctuary. . . . Then our prayer continues with specific petition: heal us, free us, save us."[4]

Often such petitions come after we're brought to the brink. That's where 1986's *The Sacrifice* finds Alexander (Erland Josephson), a former actor and now proud essayist, lecturer, and public intellectual. Alexander has gathered family and a few friends at his seaside home in Sweden, where the land is a flat expanse that melts into the water, as if it were at the end of the world. Little by little, Alexander's confidence in his worldly position is worn away, first by the celebration of his birthday (a reminder of mortality) and then by the onset of World War III, which master director Andrei Tarkovsky envisions mostly in poetic asides. (At one point the rumbling of military jets overhead knocks a placid jug of milk off a shelf.)

Alexander and his family remain huddled in his home, isolated, impotent, doomed. As global annihilation becomes imminent, Alexander, an avowed atheist, declares to God that he will give up all that he has, his family, his home, even the sound of his voice, which he once so loved, if war could be averted.

Don't mistake *The Sacrifice* for an arthouse come-to-Jesus moment, however. Hedging his bets, Alexander also visits a woman believed to be a witch, where he makes a striking deal with the devil (consummated not in her bed but while floating eerily above it). And despite all his machinations, Alexander's world—well, at least his house—still literally goes down in flames. Tarkovsky films this in an agonizing single take that pans back and forth from a distance, as Alexander and his family watch, helpless, on their knees. As the structure is engulfed over

the course of some six uninterrupted minutes, Alexander, seemingly mad, begins racing wildly to and fro, until two men in white coats arrive and manage to corral him into an ambulance. Tarkovsky still hasn't broken the sequence with a single edit, which makes it somewhat miraculous that the impassively observing camera drifts back just in time to see the house's smoldering skeleton collapse.

An apocalyptic mystic, Tarkovsky made other films, such as *Stalker* and *Solaris*, which incorporated personal collapse with an end-times aesthetic. *The Sacrifice*, true to form, concludes with an enigmatically spiritual epilogue that references John 1: "In the beginning was the Word." Is this an ironic touch for an end-of-the-world movie? Or is it a genuine gesture of witness in the wake of massive loss? *The Sacrifice*, as with most Tarkovsky films, offers no clear answer. Yet even as his movies bedevil me, they also seem to pierce through human fumbling and offer, in their poetic ambiguity, a direct line to God. There are exhilarating, unnerving sequences, as when Alexander's house burns and collapses, that speak God's "language" better than I can. And so *The Sacrifice*'s lament becomes mine.

It's not always impending apocalypse that moves a film to fall to its knees and ask why. It can also be something as mundane and intimate as aging. Much of my prayerful lamenting these days has to do with the unremarkable passing of time and the way the many blessed years of older loved ones' lives now weigh on them like a burden. Why, I wonder, must good lives of faithful service fade out not in peace and certainty, but in pain and confusion?

In both *Away from Her* and *Amour*, attentive husbands watch as their wives wither away, one to Alzheimer's disease and the

other to the debilitating effects of a stroke. The actresses in the films—Julie Christie and Emmanuelle Riva, respectively—give us enchanting women full of wisdom, warmth, and experience. And then slowly, little by little, they begin erasing them from the screen. Looking at their husbands, the gleam of recognition fades from their eyes. It's as if a cloud has settled into these marriages, obscuring what the men so desperately want to see.

In their peering, these husbands seek an answer to the same pained question: Why did this happen to my wife? The answer remains unclear. In her book *Learning to Walk in the Dark*, Barbara Brown Taylor references an anonymous fourteenth-century Christian mystic who used cloud imagery to evoke the experience of reaching out to an inscrutable God. *The Cloud of Unknowing* includes this passage: "This darkness and cloud is always between you and God, no matter what you do . . . so set yourself to rest in this darkness as long as you can, always crying out after him whom you love. For if you are to experience him or to see him at all, insofar as it is possible here, it must always be in this cloud and in this darkness."[5]

Georges (Jean-Louis Trintignant), the husband in *Amour*, is determined to keep the darkness at bay all on his own, as he takes full responsibility for his wife's care. Yet as her condition worsens and the burden grows heavier, Georges himself seems to diminish a bit each day. Then, one morning, a stray pigeon finds its way into their upper-floor apartment. A frail Georges tries to throw his coat over it. After much slow and clumsy effort, he manages to cover the bird, calm it, go to the open window, and set it free. There is mercy in the moment and, for Georges, a sense of awful clarity (which you can probably guess at, but I won't give away).

While I find a certain peace in *Amour,* others have understood the film differently. (The writer and director is Michael Haneke, whose films—from *Cache* to *Funny Games*—are nothing if not divisive.) Where I see mercy, some have claimed injustice, even sadism. Perhaps this disconnect is fitting, as things are always unsure in the cloud of unknowing. Consider Wolterstorff again, from *Lament for a Son*: "Will my eyes adjust to this darkness? Will I find you in the dark—not in the streaks of light which remain, but in the darkness? Has anyone ever found you there? Did they love what they saw? Did they see love?"[6]

In *Away from Her,* Grant (Gordon Pinsent) finds a confessional release as he experiences the slow loss of his wife, Fiona (Christie). Although they had settled into a comfortable and tender intimacy after fifty years of marriage, something first-time director Sarah Polley captures with a knowingness beyond her years, an unaddressed incident from decades earlier still hung between them.

Biblical lament is not a twelve-step program in which trauma is used to refine us. It is, rather, a way of living faithfully in a damaged world.

It takes the onset of Alzheimer's disease, ironically, to bring the past to the forefront, allowing Grant to confront and, in a bittersweet way, atone for what he did.

In this particular cloud, then, Grant discovers a certain peace, one that I pray for the older loved ones in my own life. This is not to say that Fiona's illness is God's way of forming him into a "better person." Biblical lament is not a twelve-step program in

which trauma is used to refine us. It is, rather, a way of living faithfully in a damaged world.

THE HOPE OF LAMENT

As I suggested at the start of this chapter, a defining quality of biblical lament is that it ultimately rests in an expressed hope. One of the last places you'd expect to find testimony to this is in Joel and Ethan Coen's *No Country for Old Men*. Based on a Cormac McCarthy novel about a series of drug-related killings that take place in contemporary Texas, *No Country* poses a cosmic thematic question (imagine these words in the drawl of Tommy Lee Jones's old-fashioned sheriff, who is perplexed by the rampant violence he encounters): Is this universe indifferent and arbitrary, or is there something—someone—out there who gives a damn?

The movie seems, for most of its running time, to suggest there is no one out there. Certainly that's the attitude of Anton Chigurh (Javier Bardem), the merciless hired gun who seems to represent the force of chaos in an ungoverned universe. An angel of indifference, wearing a blank expression as if rigor mortis had already set in, Chigurh occasionally lets a coin flip determine whether his victims will die or live. Near the very end of the film, he plays this game with a young woman (Kelly Macdonald), telling her to call the coin before he tosses it in the air. She refuses. "The coin don't have no say," she resolutely responds. In the face of death, she believes in something other than random chance.

This is what the author of Psalm 42 also believes. In *Lament for a Son*, Wolterstorff describes the psalm as "a lament in the context of a faith that endures. Lament and trust are in tension,

like wood and string in bow. . . . Back and forth, lament and faith, faith and lament, each fastened to the other."[7] This is faithfulness, even when staring down the barrel of Anton Chigurh's cattle gun.

Despite their reputation as snarky puppet masters, the Coen brothers often infuse their movies with this tension between dire despair and a hint of hope. Their best films have the sound of eschatological lament, in which sorrow finds a resting place in quiet anticipation of a better end. You can hear it in the songs of the downtrodden title character (Oscar Isaac) of *Inside Llewyn Davis*, a defiantly unfashionable folk singer in 1960s New York City who puts his heart and soul into every chord, despite the knowledge that his music is commercially doomed. You can hear it in the brogue of Tom Reagan (Gabriel Byrne), the Prohibition-era mob enforcer of *Miller's Crossing*, who despite being blown about by double-crossing and violence never wavers from his own moral code. Ironically, the Coen brothers' film most frequently associated with the literature of lament—*A Serious Man*, often described as a modern retelling of the book of Job—is one of the few films of theirs that is stuck in despair. Whereas Job circles back to enduring praise, *A Serious Man* concludes with an approaching tornado (and we're left with the distinct impression that it's not as benign as the "cloud of unknowing"). Truer lament comes from the Coen pictures that still find a way to weather the storm.

WHEN SOULS ARISE

Even more so than a Coen brothers' film, *12 Years a Slave* traces the full arc of prayerful lament, from hopelessness to pleading to praise. In fact, that scene at the cemetery follows this path. As his fellow slaves join in to sing "Roll, Jordan, Roll," Solomon at first resists participation, lost in his own stoic suffering. But the

singing and clapping buffet him until he's pulled into the group's rhythm and he begins to mumble along. His eyes, previously pinned to the ground, dare a glance skyward. And when his voice fully gains strength, what does he sing? "My soul arise in heaven, Lord."

This is a moment of defeat, yes: an acknowledgment that he, once a free Northerner, is truly as enslaved as those with whom he sings. It is also a gesture of rebellion, a declaration that the slavers of this earth only hold temporal power. And it is—as W. E. B. Du Bois writes in *The Souls of Black Folk*—"a faith in the ultimate justice of things," where "the minor cadences of despair change often to triumph and calm confidence."[8] With this song, Solomon's prayer of lament is complete.

MOVIES AS PRAYERS OF ANGER

James Dean was a teen siren, with the screaming red jacket to prove it. In 1955's *Rebel Without a Cause*, released shortly after his death in a car crash at age twenty-four, Dean dons his iconic jacket as Jim Stark, a brooding teenager new to the suburbs of Los Angeles. After getting into trouble in his previous town, his parents have moved the family to Los Angeles for a fresh start. But Jim quickly returns to his rebellious ways and gets arrested at the beginning of the film when he's found lying drunk on the sidewalk.

Juvenile officer Ray Fremick (Edward Platt) takes a surprisingly sympathetic attitude toward the kid at the police station, even after Jim throws a woeful, boozy punch at him. "You want to bug us until we have to lock you up," Fremick observes. "Why?" Jim's face crumples (one of the remarkable things about Dean's performance is how quickly he can turn his handsome features into an anguished mask), and he pleads, "Please lock me up. . . . I'm going to hit somebody . . . I'm going to do something." Instead of

throwing him in a cell, Fremick says, "Try the desk. Go ahead." And Jim kicks and punches the furniture in front of him until his fists are full of welts.

Usually it is Jim's parents (Jim Backus and Ann Doran) who receive the brunt of his anger. Later in the film, after a street race has resulted in another teen's death, Jim comes home tortured over his part in the accident. He finds his father asleep in front of the television, its screen a seething static. With a disdainful glare, Jim lies on the couch (red, to match his jacket) and sullenly twists his body so that his boots are up against the wall and his head is hanging over the couch's edge. When his mother enters the room, the camera cuts to his upside-down point of view. There is an air of off-kilter defiance.

Jim tells his parents what happened and says he wants to go to the police, but they insist that he keep quiet. His mother immediately demands that they move again. "But I am involved!" Jim screams. "We are all involved!" Enraged by the befuddled expression on his father's face, Jim tackles him to the ground and begins choking him, as his mother shrieks and the television flickers in the background.

WTF GOD?

Sometimes we are so mad—at others, at the world, at God—that we just want to bug him until he locks us up. And once anger ignites, it consumes us. We seethe. We lash out. We become paralyzed by our rage. Anger is a universal human emotion, but is it one that should be expressed in prayer?

Before answering that question, let's be honest and say that whether or not we *should* pray in anger, we often do. I have my own experience to prove this. "WTF?" isn't a colloquialism I use

among others, but you better believe I've prayed it. There have been times in recent years, as I've watched loved ones suffer loss upon loss upon loss, when perplexed profanity is all I can offer. And I'm in good, biblical company. Job curses the day of his birth and describes himself as a man "whom God has hedged in" (Job 3:23). David rages against his enemies, calling on God to "break the teeth in their mouths" (Ps 58:6). Jesus, whose gentleness is perhaps overplayed in Sunday school, had his own moments of outrage. It isn't difficult to imagine his words on the cross—"My God, my God, why have you forsaken me?" (Mt 27:46)—expressed in anger, especially considering they echo Psalm 22, another of David's distressed prayers.

Notice, however, that in each of these cases, God listens and responds. Job is ultimately spared and restored. David is given great victories. Jesus triumphs over death. This seems to suggest that prayer is the best place for our anger, especially if the alternatives are to take it out on others or bottle it up inside. Even contemporary theologian John Piper, who contends that we have no justification for being angry with God, suggests that we still bring our animosity before him rather than hide it: "If anger at God is in our heart, we may

> Prayer is the best place for our anger, especially if the alternatives are to take it out on others or bottle it up inside.

as well tell him so, and then tell him we are sorry, and ask him to help us put it away by faith in his goodness and wisdom."[1]

Such angry prayers have their own pitch and rhythm. They are distinct from lament in that they are not necessarily tempered

with faith that God will make a better day. Angry prayers are truncated and stunted, something less than expressions of great sadness or pleas for change. They simply, blisteringly vent. When we angrily pray, we may believe God is listening, but we're too upset to think about much more than being heard.

Perhaps it is the curt nature of such prayer that prompted Paul to encourage us to pray "without anger" (1 Tim 2:8). Yet that was within the context of worship. Surely there were days when Paul's "thorn in my flesh" (2 Cor 12:7) left him with nothing but anguish and exasperation. Christian Wiman, whose thorn has been life-threatening cancer, makes room for angry prayer in *My Bright Abyss*: "What is the difference between a cry of pain that is also a cry of praise and a cry of pain that is pure despair? Faith? The cry of faith, even if it is a cry against God, moves toward God, has its meaning in God, as in the cries of Job."

Wiman goes on to describe the "cry of faithlessness . . . the cry of the damned."[2] This is when our anger curdles into defiance, when we start blaming God for our state and begin to think we'd be better off without him. If Piper is cautious about angry prayer, it may be because it flirts with ultimate rejection—not God's rejection of us but our rejection of him.

Yet even if we deny God's existence and defy his commands, our denial and disobedience itself can be expressions of prayer. Our rebelling—for a cause or not—can be our attempt to connect with God, just as a teenager might offend his parents with a senseless act as a desperate way of expressing his rage over the separation between him and them.

Let's not forget that God listens to the "cry of the damned," to borrow Wiman's phrase. Indeed, he has the fortitude for such

cries when we do not. Those movies that are "one-timers"—to use our *Filmspotting* podcast parlance—are often difficult to revisit because they display the imagery of the damned. One of the ugliest, angriest films I've seen is 2002's *Irréversible*, a reverse-chronological account of a night in which a woman (Monica Bellucci) is raped in a Paris underpass. I wish I hadn't watched the film; it has its defenders, but I'm too faint to tease out the ways it might function as an angry prayer. Movies like this pulse with enmity in the debased acts on the screen, in the filmmakers' desires to depict them, and in the audience's revulsion while watching them. If this all sounds like a losing game, however, let's put something like *Irréversible* back in the context of angry prayer. I can't stomach such a movie, but God can. After all, he stomachs us. And part of that miraculous relationship is his attentiveness to our vilest prayers. As Walter Wangerin Jr. writes in *Whole Prayer*, "There is no better place for your rage to be stated than before a God who will not shy from you nor punish you but will change you as you have need."[3] Such strong emotions cannot be submerged, at least not healthily. It's better to vent to God, on film or in prayer.

THE ART OF ANGER

The names, with their hard consonants and curt syllables, have become infamous: Travis Bickle. Tyler Durden. The performances, by Robert De Niro and Brad Pitt, respectively, have become unsettlingly iconic. And the movies—*Taxi Driver* and *Fight Club*—are among the most fiercely debated in the American movie canon. Why do these violent tales of disturbed young men, whose inner turmoil spills out into larger society, continue to cause such a stir? Perhaps because both radiate with a startling,

familiar rage, one that we're loathe to admit might just simmer somewhere inside ourselves.

Written by Paul Schrader and directed by Martin Scorsese, 1976's *Taxi Driver* charts the mental unraveling of a man who cruises New York City's nighttime streets, unable to process the cruelty, prostitution, and drug use he witnesses. (He's also in denial over his own involvement, considering one of his regular haunts is a porn theater.) In the midst of this seedy scene, Travis Bickle sees himself as some sort of white knight. As his cab glides through the steam that rises from New York's sewers, Scorsese and cinematographer Michael Chapman give him a mythic air, as if he were floating above a medieval bog. "Someday a real rain will come and wash all the scum off the streets," he declares.

The persona Travis adopts, that of an agent of justice, complete with cropped hair and motorcycle-cop sunglasses, is convincing at first. A pimp (Harvey Keitel) suspects him of being a police officer, while the child prostitute (Jodie Foster) he hopes to save asks if he's a narc. It is with this young girl, Iris, that Travis tries to present his best version of himself. *Taxi Driver* is remembered for its grisly climax, in which Travis unleashes a burst of angry insanity, but equally telling is an earlier, far quieter moment. After hiring Iris, Travis is taken to an upstairs room, where there is a bed and enough lit candles to fill a Catholic church. Travis begs her to leave her life of prostitution behind; he can't fathom why the world works this way, why there are "lowlifes and degenerates out on the street." When she shrugs and tries to unbuckle his belt, he becomes distraught, and Scorsese's camera follows him in a frantic circle around the room. "I don't know. I don't know, I tried," he sputters. The violence that follows at the end of the film is

Travis's response to his—and the world's—moral impotence. Never mind David asking God to "break the teeth" of his enemies (Ps 58:6-8); Travis will do it himself.

All sorts of teeth are broken in *Fight Club*, a diatribe against the dehumanization that comes from a life of rampant consumerism. An anonymous office worker, played by Edward Norton and identified in the credits as The Narrator, has dutifully followed middle-class America's recommended path: he works longs hours in a meaningless job, mainly so he can buy unnecessary stuff. Yet even though he's on the verge of fully furnishing his condo, he's still dissatisfied and increasingly angry. (He calls it the "sofa problem.") The Narrator finds an outlet for his angst when he meets Tyler Durden (Brad Pitt), a gleeful malcontent who helps him start an underground fight club where men try to find identity and meaning by beating each other to a pulp.

Directed by David Fincher, with cinematography by Jeff Cronenweth, *Fight Club* mostly consists of smeary grays and bruised blues. It's a morose color scheme, one that would hide in the shadows if the filmmakers didn't also employ harsh fluorescent lighting to expose the dreary hue. Alex McDowell's production design, meanwhile, emphasizes damaged taverns and damp basements, so that it feels as if we've fallen inside a stomach awash in acid. *Fight Club* is an ulcer laid bare.

Acid of a sort comes into play in a crucial early scene, in which Tyler subjects The Narrator to a chemical burn as an initiation rite, spreading a powder on the back of his hand and holding him still while it eats away at his skin. As The Narrator convulses in agony, Tyler grins and offers, "It's only after we've lost everything that we're free to do anything." It's a twisting of

Gospel truth; rather than see suffering as a way to salvation, Tyler sees it as a perverse path to power. *Fight Club*'s anger is so potent it feeds on pain.

WHEN WORDS FAIL

Enough macho misery: let's consider a feminine prayer of anger. I was in college when director Jane Campion's *The Piano* came out in 1993, and it upended my sense of what the movies could be. Not because the film was a period piece from New Zealand, but because of its distinct femininity. Holly Hunter plays Ada, a mute Scottish woman with a young daughter named Flora (Anna Paquin). Sold by her father into marriage, Ada is shipped off, along with her daughter and her beloved piano, to meet her new husband at his frontier home in New Zealand. Arriving on a wild and windswept shore, Ada is quiet, but hardly demure. Her firm jawline is etched in anger. Everything that *The Piano* considers— power, love, sexuality, defiance—is filtered through a woman's perspective, a lens that was far different from my own gender bias and that of the vast majority of the movies I had, up until that point, seen.

In the book of Job, near the beginning of his suffering, Job wonders,

> Why is life given to a man
> whose way is hidden,
> whom God has hedged in? (Job 3:23)

The same question could be asked by a woman who has been married by mail to a stranger and sent to live with him in the wilds of a foreign land. When Ada arrives, even her sole source of solace is taken from her, as her husband Alisdair (Sam Neill)

declares that her piano is too heavy and leaves it stranded on the beach. A shot of the piano abandoned at the water's edge is the movie's defining image, both a lone symbol of civilization, surrounded and threatened by nature's chaos, and also a metaphor for Ada's voice, so disregarded that it is left to wash away. If *Taxi Driver* and *Fight Club* expressed masculine anger in a way I could inherently recognize, *The Piano* offered me a hint of what feminine anger might be.

Desperate to play the piano before it succumbs to the ocean, Ada convinces a neighbor, Baines, (Harvey Keitel) to take her and Flora to it one day. The three of them spend hours on the beach, Flora doing cartwheels in the sand and Ada playing the piano while Baines watches and listens in wonder. Michael Nyman's piano score is its own masterwork within the movie. With reaching notes that roll one upon the other like the wild waves unfurling onto the beach, the music casts a vision of a better day. As the sky grows dark and the three of them gather their things to head home, it's no surprise that the camera pulls back to reveal that little Flora has designed the shape of a seahorse in the sand while her mother has played. Ada's music has made something possible other than industry (the goal of frontiersmen like Alisdair and Baines). She's unleashed creativity.

This sequence proves to be a rare idyll for Ada, who becomes something of a pawn between the two men. The oblivious Alisdair sells the piano to the entranced Baines, who tells Ada he will give it back to her one key at a time in exchange for acts of affection. The sessions that follow are pure Campion: a provocative intermingling of psychology and sexuality, so that the obviousness of melodrama moves aside to make room for the way complicated emotions play out in real life. Underneath each moment, Hunter

wordlessly stokes a smoldering anger—against the patriarchal society that has led her to this place, against the uncaring husband who considers her a mail-order object, against the admirer who would barter for her body, and, in the film's near-tragic finale, against herself.

In the end, Ada once more echoes Job:

Therefore I will not keep silent;
> I will speak out in the anguish of my spirit,
> I will complain in the bitterness of my soul. (Job 7:11)

The beauty of *The Piano* is the way it empowers this angry woman—who hasn't a word at her disposal—to speak.

THE ANGER OF THE EXPLOITED

Another angry movie prisoner, one of the most iconic, is King Kong. His journey, however, is the opposite of Ada's. Kidnapped from his jungle home, he's brought to the heart of modern civilization: New York City. The 1933 movie paints Kong as a tragic figure, a misunderstood monster with the bad fortune of falling for Fay Wray. But at the end of the day, he's mostly a big, angry gorilla. Chained before a gaping audience and subjected to the relentless assault of photographers' flash bulbs, it's no wonder Kong loses it and takes his anger out on New York.

Even today, in an era of seamless CGI effects and 3D "realism," there is something showstopping about Kong's rickety, stop-motion assault. The sequence lingers in our memory because of the way special effects pioneer Willis O'Brien evokes the emotions that are driving the action. Escaped from his cage and on the loose in the city, Kong's anger is palpable and justified. Notice the little gestures of rage that the animators emphasize,

as when Kong takes off his steel belt and hurls it to the ground in disdain, or when he gives the train car he's derailed a few extra punches for good measure.

Why does Kong take his complaint to the top of the Empire State Building? So the whole world can hear. Like *Godzilla*, *King Kong* is a creature feature that speaks to the missteps of humankind. (If I'd take Kong over Godzilla in a fight, it's because Kong's rage would trump Godzilla's sadness.) The ire in *King Kong*, as well as its offspring in the *Planet of the Apes* franchise, is ultimately directed at the audience and our own failure to properly steward creation. *King Kong* is a prayer of anger over the way we've gotten the dominion thing wrong (Gen 1:26). The great beast's fury stands in for outrage over the way our exploitation of creation has run amok.

Only slightly less caged than Kong are the sideshow performers in 1932's *Freaks*. Barely tolerated members of a traveling circus, they earn a living by allowing customers to gape and guffaw as they display their various deformities. It is telling that director Tod Browning never films these "acts," but instead only depicts the performers backstage, living their everyday lives. He still showcases their talents, but in offhanded ways, as when the legless and armless Prince Randian, playing The Living Torso, rolls and lights his own cigarette while having a casual conversation. Some measure of dignity is preserved, then, so that *Freaks* itself cannot count as an act of exploitation.

Given Browning's decision to cast real-life circus performers rather than experienced screen actors, the movie isn't known for the quality of its acting. Still, there is a remarkable moment featuring Hans (Harry Earles), the little person who has fallen for the devious charms of Cleopatra (Olga Baclanova), the circus' trapeze

beauty. It isn't until after he has married her that he realizes she is after his money and, indeed, has been slowly poisoning him. Left bedridden and bereft in his wagon, Hans slowly adopts a creepy smile and mimics the sickly sweet way Cleopatra talks to him. His face then darkens, his voice deepens, and in a hateful rasp he spits out what he knows she really thinks: "Dirty . . . slimy . . . freaks!"

Freaks depicts a churning cycle of anger in which "normal" society's disgust and exploitation of a group of outsiders breeds a desire for vengeance on the part of the exploited. And so the movie comes to its infamous conclusion, in which Hans and his compatriots devise a plan for getting payback from Cleopatra and Hercules (Henry Victor), the strongman who has been her accomplice. Browning stages the revenge sequence during a terrible storm, as the circus's wagon train gets stuck along a muddy road. As the rain beats down and the lightning flashes, Hans's friends close in on Cleopatra and Hercules. The two flee, but the muck and mire slow them down. Even Half Boy (Johnny Eck), who is missing a lower torso and "walks" on his hands, has no trouble catching them.

Samson, the Bible's strongman, once offered an angry prayer in search of deadly vengeance. After being drained of his strength, he is captured by the Philistines, who cruelly gouge out his eyes. In an Old Testament variation on the freak show, he is forced to perform before a crowd of jeering thousands, where he pleads, "Sovereign LORD, remember me. Please, God, strengthen me just once more, and let me with one blow get revenge on the Philistines" (Judg 16:28). And the walls come down, just as they do for Cleopatra.

Our angry prayers sometimes curdle in this way. It's one thing to rage against the "universe" (a vague target that can

serve as a tentative stand-in for God), but when we have fellow humans in our sights—be they defilers of creation, like Kong's captors, or personal tormentors, as Cleopatra was to Hans—our prayers can turn from mournful laments to hissed requests for revenge. In one of those murderous Old Testament passages that gives me pause, God answers Samson's prayer and allows him to obliterate his enemies. Some read that story as evidence of God's righteous judgment. But let's not forget that in carrying out his angry prayer, Samson brought about his own death.

TOUCHES OF EVIL

If there is a genre that best represents Christian Wiman's "cry of the damned"—those angry prayers that flare into defiance—it's film noir. Emerging from post-World War II Hollywood and often based on crime novels by the likes of Dashiell Hammett and Raymond Chandler, these movies have a simmering anger beneath their stylized design. Resentment and jealousy fuel the action, as noir characters often feel they've been dealt a bad lot in life or have been left on the outside of respectable, daytime society. And so they act out, ignoring community rules and defiantly playing by their own.

The audience's guide through this ugly underworld is usually a dented representative of law and order. In both *The Maltese Falcon* (based on Hammett) and *The Big Sleep* (Chandler), Humphrey Bogart plays a weary private detective who is only a slight step above everyone else on the ladder of morality (mostly because "everyone else" includes murderers, thieves, and double-crossing femme fatales). Hardly a staunch defender of the establishment, yet not quite as mired in the muck as those he's

investigating, the noir antihero strives above all to save his own skin. If he also manages to make a little money, all the better. And if it isn't too much of an inconvenience, he might even enforce a bit of justice along the way.

In other words, these guys have a bit of Jonah in them. The Old Testament prophet knew what was right, but you could hardly say he prioritized it. Commanded by God to preach to the lost people of Nineveh, Jonah fled in the opposite direction. It wasn't that he approved of the Ninevites (their depravity disgusted him), he simply didn't want any part of it. What's more, he didn't feel that the city deserved the grace God intended to offer. And so Jonah chooses to remain a prophet apart, embarking on a ship to Tarshish, hiding below deck and falling into—if not *The Big Sleep*—a "deep sleep" (Jon 1:5).

Of course God sees Jonah there, rousing him with a terrible storm. Confessing to his shipmates that it is his disobedience that has caused the life-threatening weather, he tells them to throw him overboard so that the winds will be quieted. Over he goes, sinking into the dark sea, where he is swallowed by an enormous fish and left to rot in the utter blackness of its belly.

This part of Jonah's story is a precursor to one of the distinctive characteristics of film noir: its inky, black-and-white cinematography. A term that originated with French film critics, film noir literally translates as "black film." These movies mostly take place in the dark bellies of big cities, where streetlights cast sharp shadows on lonely alleys and unpromising doorways. Offices feature Venetian blinds, the better to slash contrasting lines across uneasy faces. Notice how few noirs feature scenes that take place during the day.

Some of them don't even take place above ground. *The Third Man*, with cinematography by Robert Krasker, makes expressive use of Vienna's vast, cobblestone sewer system, where a climactic chase scene takes place. American abroad Holly Martins (Joseph Cotten), having been deceived by his friend Harry Lime (Orson Welles), tags along after the police as they chase Lime through the tunnels. Silhouetted figures dart back and forth along the walls; the long, curved ceilings reflect what little light there is in staggered strips. Cornered at one point, Lime opens fire on the police and takes a bullet in return. Martins approaches and raises his gun. The two men lock eyes and Lime wearily nods, just before director Carol Reed cuts away to a shot of the police chief. Our eyes are no longer useful in this darkness; now we must rely on our ears.

If we flee from God in our anger—rather than seek him, even if it's in the form of an angry prayer—we'll find ourselves mired in a pit, something like the sewers of Vienna or the belly of a whale.

We hear a shot, and then Martins emerges from the tunnel unharmed. Was his killing of Lime an act of justice, mercy, or anger?

We usually associate anger with the color red (James Dean's jacket), but blackness captures its essence just as well. If there was such a thing as an angry prayer book, it would have a black cover. In Psalm 88, the psalmist snarls at God,

> You have put me in the lowest pit,
>> in the darkest depths.
> Your wrath lies heavily on me;
>> you have overwhelmed me with all your waves. (Ps 88:6-7)

His imagery reflects both Vienna's tunnels and Jonah's watery would-be grave. If we flee from God in our anger—rather than seek him, even if it's in the form of an angry prayer—we'll find ourselves mired in a pit, something like the sewers of Vienna or the belly of a whale.

A TEEN TORN APART

Back at that police station in *Rebel Without a Cause*, Dean's Jim Stark awaits the arrival of his ineffective parents. When they show up and quickly start bickering, he silences them by screaming, "You're tearing me apart! You, you say one thing, he says another and everybody changes back again!"

Such outbursts have cemented Dean's legendary status as a screen poet of teen angst, yet also worth remembering is the gentle attitude of Edward Platt's juvenile cop, the one who offered his desk as a punching bag. There is a tender moment, after he has pulled Jim into his office for a break from his parents, when the cop makes a quiet offer: "Jim, look, will you do something for me? If the pop starts blowing again will you come and see me before you get yourself in a jam? Even if you just want to talk, come in and shoot the breeze. It's easier sometimes than talking to your folks."

"Okay," Jim mumbles in response.

"Any time, night or day," the officer insists.

The exchange reminds me of the old hymn "What a Friend We Have in Jesus," which emphasizes Christ's comfort with these lines: "What a privilege to carry / Everything to God in prayer." The policeman in *Rebel Without a Cause* is offering Jim something similar: a way to pray, even in anger.

MOVIES AS PRAYERS OF CONFESSION

Near the end of *Toy Story*, bickering playthings Woody (voiced by Tom Hanks) and Buzz Lightyear (Tim Allen) have been kidnapped by Sid, a cruel and abusive neighborhood boy. At this point, despite Woody's continued protests to the contrary, Buzz still believes that he's a real space ranger and not a toy. His confidence is shaken, however, by a Buzz Lightyear commercial that appears on Sid's television. As he watches in confusion, the ad is reflected on his clear plastic helmet, allowing for an ingenious, half-second moment in which the actual Buzz appears to be looking directly at the grinning, confident, and deluded Buzz from the commercial. Sometimes, no matter how hard we try to avoid it, we must come face to face with our true selves.

The real kicker for Buzz comes with the ad's disclaimer: "Not a flying toy." Refusing to admit this declaration of his deficiency, Buzz jumps up on the railing at the top of the stairs. He launches himself into the air with confidence, but of course he crashes to the hard tile below, breaking off one of his arms. He lies there

on the floor, damaged, while the soundtrack carries the plaintive chords of Randy Newman's "I Will Go Sailing No More."

WHO, ME?

In *The Path of Celtic Prayer*, Calvin Miller outlines three steps to confessional prayer. The first is a desperate longing for God. The second is agreeing with God that our sin is sin, that we are not perfect beings. The third is serving God in the world in response to our forgiveness.[1] As with Buzz, it's the middle step that most of us find so difficult. Yearning never ceases, we just give it different names. (These days, people say they're "spiritual but not religious.") Serving God is a common response for those who, after confession and forgiveness, express their gratitude by offering their obedience. But agreeing that sin is sin? It just seems so passé.

We don't even like to say "sin" out loud. It is, in these days of relativism and political correctness, the ultimate trigger word. And this isn't only a secular attitude; every day I find some way to justify the thoughts and deeds that keep me apart from God. While I may admit that I have faults or "things I'm working on," I mostly live my life in denial of the full weight of my brokenness.

And yet I feel that weight, even if I don't admit it or acknowledge it in the moment. In fact, I often feel it the most *after* it's been lifted via confession—just as the pressing burden of a stuffed backpack doesn't fully register until the straps slide from our shoulders at the end of a long hike. This is because, although sin often reveals itself in the things that we do, its root lies in who we are.

Let's back up, then, and consider sin not from the perspective of the fire-and-brimstone preacher who focuses on

offensive acts, but from the perspective of the apostle Paul, who understood the existential state of unease from which sinful behavior often springs. In Romans 7:18 he confesses, "I know that good itself does not dwell in me, that is, in my sinful nature. For I have the desire to do what is good, but I cannot carry it out." Just as nearly everyone agrees that there is something wrong with the world, we all know—when we're alone, when we do what we want at the expense of others, when we finally realize we're not the noble Buzz Lightyear we've tried so hard to be—that something is also wrong with us. Something in our very nature, no matter how hard we try, is preventing us from being in right relationship with God and in shalom with each other.

Of course the good news of the gospel is that Christ's work on the cross has paved the way for such relationship to be restored (Rom 7:24-25). As we wait for the day when we will finally enjoy the full presence of God, the reality is that our sin continues to keep us at a distance. And so confession is a continual thing. And where does such confession take place? Prayer.

THE ART OF CONFESSION

Don't worry: this chapter will not be a catalog of movie characters behaving badly and being punished for their actions. I don't favor the fire-and-brimstone approach. And anyway, sinners watching other sinners onscreen, cheering for their castigation, strikes me as a deeply hypocritical endeavor.

More interesting—and more evocative of the gospel of grace— are those films that acknowledge a separation from God and a desire to live closer to him. "We need to go deeper than simply going through a list of personal violations of rules," writes

Kenneth Leech in *True Prayer*, "looking more closely at the corruption of the will than at the particular external acts committed. Sin does not consist only in transgression of external laws, but in an inner alienation of the personality from God."[2]

What does that look like onscreen if not a story that repeatedly raps its characters on the knuckles? Well, I would offer that films that function as confessional prayers are, instead, those that capture epiphany moments for their characters: instances when they admit and fully bear the weight of the reality that they themselves are inextricably tied up with the awfulness of the world. It's when they acknowledge that they've messed up because they're messed up, and that they're incapable of correcting things on their own.

Messiness, then, will be a common quality of such films, as it is in confessional prayer. Calvin Miller notes in *The Path of Celtic Prayer* that "confession is the prayer that is hardest to formalize. When the form remains flexible and unplanned, the confessor can achieve that atmosphere of openness that keeps us real."[3] This suggests that films that function as prayers of confession will be ragged, impulsive things. And it should relieve any concern that confession is too liturgical, too formal a function of Christian practice, to be reflected in something as common as the movies. Once we grant films this

Films that function as confessional prayers are … those that capture epiphany moments for their characters: instances when they admit and fully bear the weight of the reality that they themselves are inextricably tied up with the awfulness of the world.

ability, we begin to see confessional gestures in many places. I think of Marlon Brando's brutish Terry Malloy in *On the Waterfront* admitting, "I coulda been a contender . . . instead of a bum, which is what I am." Or the corporate confession that takes place in *Platoon*, where director Oliver Stone drew on his own experiences in the Vietnam War to force a nation to confront its crimes. These are films that recognize a longing for things to be made right, that admit a wrong has been done and that find a new freedom in expressing penitence. Celtic or not, they follow the path of confessional prayer.

GIVING UP THE GUN

When you think of the Western genre, confession isn't the first thing that comes to mind. After all, these are pictures with vast vistas and few words, featuring no-nonsense figures such as Clint Eastwood's "man with no name." Or go back to an earlier era and another towering cinematic icon: John Wayne. His cowboys were full of "true grit," not apologies. Did men like this have any use for confession?

Actually, they did. In *Unforgiven*, Eastwood's masterpiece as a director, he plays a retired hired gun who agrees, one last time, to kill for money. Winner of the 1993 Oscar for Best Picture, *Unforgiven* is often read as a confessional critique of the mythologized movie violence that had defined Eastwood's career up until that point. Then there is Wayne's *The Searchers*, in which he plays a Confederate veteran on a years-long quest to rescue the niece who has been abducted by Comanches. Released in 1956, it features a "hero" who is driven as much by his bitter prejudice as his bravery. Uncomfortably mixing the two qualities, especially in the persona of John Wayne, director John

Ford turned *The Searchers* into an admission of the casual racism that had been part of the Western genre since its inception.

Not that Eastwood's William Munny or Wayne's Ethan Edwards ever express penitence in those respective films. Indeed, they both emerge as violent victors: Munny leaves a pile of bodies behind him in a saloon; Edwards scalps the Comanche chief who took his niece. Yet in these movies' subtle deflating of their central figures, as well as their depiction of violence as ugly and corruptive, both films offer a prayer of confession. When Edwards, having delivered his niece back home, stands on the porch of her family's cabin in the famous final frames of *The Searchers*, you *could* see it as a triumphant moment. Or you could notice that while the rest of the family enters the safety of the home, the door closes on Edwards, leaving him outside, alone. Perhaps he's not so much a hero, but a threat.

Wayne would tweak his star persona once again in 1969's *True Grit*, where he plays an alcoholic US marshal hired by a young girl to capture the man who murdered her father. Wayne is fine in the part—good enough to win an Oscar—but I prefer Jeff Bridges's take on the character in Joel and Ethan Coens' 2010 remake of the same name. Bridges's perpetually soused Rooster Cogburn, a pretty good shot when he manages to put the jug down, agrees to work for fourteen-year-old Mattie Ross (Hailee Steinfeld) mostly because he sees it as an easy way to earn more drink. Yet the task ultimately proves to be an occasion for Rooster to confess his true character. "All I've heard out of you so far is talk," Mattie says to him early on. "I know you can drink whiskey and snore and spit and wallow in filth and bemoan your station. The rest has been braggadocio. They told me you had grit and that is why I came to you." Will Rooster turn from his

wallowing to serve a more respectable purpose? And might both he and Mattie discover that this purpose could be something greater than cold-blooded revenge?

Perhaps this makes *True Grit* sound like a feel-good story, but be assured that the Coen brothers' version decidedly is not. As our consideration of *Miller's Crossing, A Serious Man,* and *No Country for Old Men* has already shown us, Joel and Ethan Coen are primarily Old Testament filmmakers. Their movies are governed by harsh moral codes, with only fleeting hints of a coming grace. In fact, taken as a whole, their filmography mirrors the cycle that defines the first half of the Bible, in which God's chosen people fall away from him, are called to confess, receive forgiveness, but soon fall away again. You can follow the pattern by following the prophets. Nehemiah catalogs the history of Israel's sins, as well as God's continual, forgiving actions (Neh 9). Daniel offers a prayer of penitence on behalf of God's people and pleads for his mercy (Dan 9). Ezra admits in prayer that "not one of us can stand in your presence" (Ezra 9:15), while Isaiah concedes that "all our righteous acts are like filthy rags" (Is 64:6).

Rooster's mission—to catch the man who killed Mattie's father—has the appearance of righteousness, but the stench of a filthy rag. His low point in *True Grit*, which is both an act of selfishness and a cruel confession of sorts, comes after they've lost their quarry's trail and he drunkenly decides to give up the chase, even threatening to abandon Mattie in the wilderness. "I'm a foolish old man who's been drawn into a wild goose chase by a harpy in trousers and a nincompoop," he grumbles. "I bow out."

Though misguided, Rooster's confession is followed by an opportunity for obedience. He wakes the next morning to find Mattie kidnapped by the very man they had been seeking, now

joined up with a murderous gang. Rooster rouses himself to attempt a rescue, and in the ensuing turmoil Mattie falls into a nest of poisonous vipers and gets bitten. Life, not death, becomes Rooster's new objective, as he lifts the slumped Mattie onto his horse and they race away in an unlikely effort to bring her home before the venom does its deadly work.

True Grit pauses at this point to indulge in an eerily beautiful montage, in which we experience this frantic ride from Mattie's hallucinatory point of view. Racing through a field, they pass ugly corpses full of bullet holes; these are members of the gang and victims of Rooster's gun. As they journey on, the setting sun blearily melds into a blue night. The image gives way to something mythical, as the riders' silhouette appears against an endless, starry expanse. Mattie mumbles, "He's getting away," as if they are pursuing her father's killer and she is still stuck in the poisonous cycle of revenge. All along, the soundtrack features a simple piano rendition of "Leaning on the Everlasting Arms"—*True Grit*'s recurring musical motif and one of the Coens' teasing references to New Testament grace. The horse falters, and Rooster pricks it with a knife to urge it on. Eventually the horse's legs buckle, marking this as a sacrificial journey, and Rooster shoots it to put it out of its pain. He walks the final stretch with Mattie, his offering, in his arms.

TO CONFESS A KILLING

True Grit's confession takes place in a land of myth—the American West. In *The Act of Killing*, Joshua Oppenheimer's documentary about the mass murders that were carried out in Indonesia from 1965 to 1966 in the name of anticommunism, we witness a real-world confession, one that reminds us that true disclosure can be an ugly, revolting experience.

Because those who conducted the killings in the 1960s were never prosecuted (and are indeed celebrated by the government for their actions), Oppenheimer was able to talk to the perpetrators on camera, where they brag about their crimes and even restage the murders in intimate detail. One of these killers, Anwar Congo—now a lanky, elderly man with puffs of white fuzz for hair—proudly demonstrates how a length of wire would be tied from a pole to a victim's neck and then yanked, because that method resulted in the least amount of blood. The pièce de résistance of the film, if that's the right phrase, is an elaborately costumed musical fantasy "directed" by some of these men, in which one appears as some sort of benevolent god and another is dolled up in drag.

It's all hard to fathom and almost as arduous to watch; *The Act of Killing* verges on being a "one-timer." I initially watched it on one of those harried deadline days when my only option was to view it via an online screening link on my laptop. Sitting on my screened-in porch, I unexpectedly tumbled from domestic comfort into contemporary apocalypse of the sort most of us only know when third-world news manages to get some time on our television screens. Watching *The Act of Killing*, we become something like the prophet Habakkuk, who wondered to God, "Why do you tolerate wrongdoing?" (Hab 1:3). And we search, achingly, for his answer in the images, hoping for justice of some kind to be served or, at the very least, the tiniest glimmer of conscience to emerge.

Something like that does happen in the movie's wrenching final moments, when Congo returns one night alone to the site of those wire killings. Amid the silence, something of a qualified confession emerges: "I know it was wrong, but I had to do it."

More telling is the sputtered coughing and spitting that involuntarily punctuates his words. Eventually Congo succumbs to a fit of retching, leaning over so that whatever he expels doesn't soil his expensive suit. It's almost as if God is responding to Congo's confession by conducting an onscreen exorcism.

AMY SCHUMER IS NOT OK

Perhaps I should lighten things up a bit. Let's take a break from disturbing documentaries and consider something different: confessional comedy. I've always been a sucker for the sneaky smarts of dumb comedies. Beneath the broad humor, crude gags, and sharp one-liners often lies an instinctual intelligence. Comedy can capture the truth of the world in a flash.

Such is the case with *Trainwreck*, written by and starring Amy Schumer, a specialist in comic confession. Here she plays a promiscuous and hard-drinking magazine writer, also named Amy, whose routine of wanton abandon includes this unconvincing mantra: "I am fine. I am in control." *Trainwreck* traces Amy's journey from that early declaration to the following echo of Romans 3:23, which she utters near the movie's end: "I'm not OK. I'm broken."

This is hardly a crime-and-punishment comedy, however, some sort of finger-wagging cautionary tale in which a misbehaving character is corrected by outside forces. Instead, *Trainwreck* is attuned to the nuances of confessional self-awakening. Amy's penitence comes about because of inner distress rather than imposed societal rules. In fact, if anything, contemporary society applauds the "freedom" she's extravagantly exercising. Consider another early claim Amy makes: "I'm just a modern chick who does what she wants."

Amy's tendency toward denial is funny and innocuous at first, as when she claims that she's had nothing to eat all day and then impulsively rattles off a seemingly endless list of the unhealthy items she's consumed before lunch. As the movie progresses, however, her burden grows weightier. During Amy's worst moments—when she's caught lying to her boyfriend about the other men whose names are listed in her phone, for instance— her aloof façade crumbles, and little bits of honesty keep spilling out. Schumer turns such scenes into bravura spirals of sputtering confession. As her comically brazen lies wind down into mumbled concessions, you'll notice there's a quiet epiphany at the end.

Interestingly, what helps bring about such self-realization is not scolding but the good news of a better way of living. Amy strikes up a comfortable rapport with Aaron (Bill Hader), a sports doctor she interviews for her magazine. (One of their funny, teasing exchanges has to do with the societal value of professional cheerleaders. Aaron sees them as athletes; Amy's not a fan.) When they begin dating, she finally gets a sense of what it feels like to be in real relationship with another person, *as* another person, rather than a personal gratification device. A bit dazed by the experience, she protests to her sister and claims, "He's too nice." Her sister's wonderful answer? "He's the perfect amount of nice that you deserve." Amy is experiencing the sort of positive confessional awakening Kenneth Leech describes in *True Prayer*: "There is the world of difference between a sense of failure which leads to overpowering guilt and despondency, and a sense of failure which issues in penitence and joy."[4]

Still, it takes a while for Amy to fully accept that she could not only be lusted over but also loved. Being a romantic comedy, *Trainwreck*'s third act awkwardly contorts the plot to separate

Aaron and Amy by having her illogically sabotage the rela-
tionship. Yet the movie makes up for it with a delightful climax
that functions as an act of penitence on Amy's part. After vis-
iting some of his clients at a New York Knicks basketball game,
Aaron is wandering the empty, postgame court alone when the
team's cheerleaders suddenly emerge from the tunnel and begin
to perform a routine. In the midst of the squad is Amy, in full
uniform, a beat or two behind the pros but working as hard as
any of them. As the number gets more elaborate and Amy's part
more complicated, Aaron beams in response, especially enjoying
the way she works his favorite song, Billy Joel's "Uptown Girl,"
into the repertoire.

Exhausted when she's done, Amy almost falls into Aaron's arms.
"As it turns out I am in terrible physical shape," she admits. "I am
sweating more than I am proud of." She goes on to breathlessly
explain that she had been practicing for the performance to dem-
onstrate her sense of commitment, to show him that she can
pledge herself to a challenging task and stick with it. Smiling at
her audacious honesty, Aaron assures her: "I got the metaphor."

Trainwreck ends as so many romantic comedies do: in a state
of dizzy bliss. But for once, the ending feels earned. The movie
understands the pleasure that can come from genuine confession—
never mind that we usually associate it with terror. I can distinctly
remember, as a little kid, being petrified in the moments before
admitting to my parents that I had done something wrong (or,
more likely, knowing I was about to be found out). Yet just as vivid
in my memory is the feeling that followed my (perhaps coerced)
confession, a feeling that went beyond relief and even approached
joy. A blockage had been removed; right relationship with my
parents had been restored. For *Trainwreck*'s Amy, confession not

only allows for right relationship with Aaron but also with herself. She is not fine. She is not in control. But more importantly, she's not lying to herself about it.

MASTER OF SUSPENSE . . . AND CONFESSION

I'm not going to share any of my confessions here, but I will assure you that I've never had to confess a crime on the level of a Hitchcock character. Murderers of all kinds populate his pictures, and if these movies have such a lasting power it may be because they often align the audience's perspective not with the victims but with the perpetrators. By implicating us, they burrow into our guilty consciences. Think of Farley Granger and Robert Walker sharing a momentary admittance of murderous desire in *Strangers on a Train*. Or Anthony Perkins fully shedding sanity—and subterfuge—at the end of *Psycho*. In many ways, Hitchcock's films put the screws on their characters (and the audience) until we are all forced to come clean. Because so many of his movies are driven by a palpable sense of guilt, a fair number also involve a contorted sort of confession.

Rebecca, from 1940, is especially insidious in this manner. In this Best Picture winner, Joan Fontaine plays a young woman who marries a wealthy widower (Laurence Olivier), only to be haunted by the memory of his first wife, Rebecca, when she moves to his elaborate English estate called Manderley. One of the more sinister elements of the movie is the way it frequently positions Fontaine's character as the guilty party: the usurper, the defiler, the one tarnishing the name and memory of the "true" Mrs. de Winter (we never see her onscreen).

All of this is reinforced in one of the film's creepiest scenes, in which the new Mrs. de Winter sneaks into the private bedroom

of the former Mrs. de Winter. Opening the ornate door, she finds a grand room with vast sets of windows—all curtained with translucent fabric so that the daylight creates odd, vaguely birdlike shadows. Mrs. de Winter wanders about, opening one of the windows and touching the cosmetics that have been left on the vanity, as if the former Mrs. de Winter might return at any time. Then she sees another shadow near the door's entrance—that of Mrs. Danvers (Judith Anderson), the needling housekeeper who has made it no secret that she despises her new mistress.

Danvers immediately takes advantage of the trap she set. When Mrs. de Winter claims she had only come in after she noticed that a window wasn't closed, Danvers replies, "Why did you say that? I closed it before I left the room. You opened it yourself didn't you?" Danvers then proceeds to give a tour of the space—"the loveliest room you've ever seen"—opening more curtains, revealing more shadows, further exposing Mrs. de Winter's supposed trespass. Then things get really weird, with Danvers taking out a fur coat and rubbing its sleeve on Mrs. de Winter's face, as well as showing her lingerie that had been made by the "nuns of St. Clair." Making Mrs. de Winter sit down at the vanity, she offers another politely stinging accusation: "Oh, you've moved her brush haven't you?"

As much as Danvers (and Hitchcock) try to implicate the new Mrs. de Winter in some sort of crime, the "dread secret" promised in the trailer for *Rebecca* lies elsewhere. There are things to be confessed at Manderley, yet they remain stubbornly buried for most of the film. Then, when the secret becomes too much to bear, *Rebecca* erupts. Rather than confession, however, the movie ends in an act of vengeance, in which one of the characters sets the entire estate ablaze. The climax of *Rebecca*

answers the movie's particular mystery, even as it mirrors the way each of us will deny, cover up, and pretend, until everything goes down in flames.

ADMITTING TO "THE OTHER WOMAN"

An even earlier consideration of confession—one from the silent era, in fact—is *Sunrise: A Song of Two Humans*. The story is as simple as the artistry is elaborate: a married farmer (George O'Brien) is involved in an affair with a "Woman from the City" (Margaret Livingston), to the dismay of his faithful wife (Janet Gaynor). Director F. W. Murnau paints with the bold strokes of German expressionism, so when the husband sneaks out of the house to meet the other woman, he walks through a misty, moorish field, the full moon shining through the fog like a spotlight on his sin. At their murky rendezvous, she suggests he sell his farm and move with her to the city. "And my wife?" he asks. The intertitles themselves take on a ghoulish form as they drip from the screen with her answer: "Couldn't she get drowned?" A plan is set, and the husband agrees to take his wife on a boat ride in order to commit the act.

Back home, as the husband sits on his bed consumed with guilt, Murnau creates one of *Sunrise*'s most fantastic visual flourishes. The other woman's ghostly image is superimposed onto the screen behind him, so that she seems to be whispering in his ear and her arms appear to wrap around his chest. It's the movie's pivotal moment, and one that is poised for prayer. As Richard Foster writes in *Prayer: Finding the Heart's Home*, "We should learn to pray even while we are dwelling on evil. Perhaps we are waging an interior battle over anger, or lust, or pride, or greed, or ambition. We need not isolate these things from prayer.

Instead we talk to God about what is going on inside that we know displeases him."[5]

This is not the path the husband chooses, at least not yet. As the tempting apparition enfolds him, his brow slightly furrows. Pressing his fists to his temple, he finds his wife and invites her out on the boat. Once on the lake, he sits hunched and moves slowly, as if he is under a spell. He eventually sets down his oars and approaches his wife, a slow horror dawning on her face. But at the last moment he pauses. At the edge of the act, he chooses confession over crime. And so he falls down and furiously rows to the other side of the lake, where the wife flees to the city. It's there, in the supposed heart of sin, where further confession will be made and atonement will be attempted. For to confess is not simply to change but to first face and fully deny the false person we were trying to be.

To confess is not simply to change but to first face and fully deny the false person we were trying to be.

BUZZ LIGHTYEAR'S BURDEN

Things get worse for Buzz. Finding him damaged at the bottom of the stairs, Sid decides he might as well have fun by further destroying the toy, so he straps a firework rocket to Buzz. When rain delays his plans, Sid leaves a despondent and condemned Buzz on a table in his bedroom overnight.

Woody is there, trapped in a crate, and he tries to convince Buzz that even though he's imperfect, he's still loved: "Being a

toy is a lot better than being a space ranger." Glancing from the corporate stamp on his wrist ("Made in Taiwan") to the hand-lettered inscription on the bottom of his foot ("ANDY"), Buzz comes to understand that his true identity lies not in the façade of a fictitious hero but in being claimed by someone else, someone who loves him despite his faults.

Having confessed that he's been living a lie and is not the unassailable hero from TV, Buzz doesn't become paralyzed and morose. Instead he is energized, enough to help Woody escape from the crate. They flee Sid's house just in time to see their true owner Andy and his family pulling away in a moving truck. Buzz and Woody race to catch the truck, even enlisting a radio-controlled car to help, but they can't keep up. Then Buzz re-members the rocket strapped to his back. He ignites it, sending them hundreds of feet into the air. Just before it explodes, Buzz opens his wings and cuts them loose. Released from his burden, he and Woody float free, eventually, improbably, plopping through the sunroof into the loving acceptance of Andy's car.

--- CHAPTER SEVEN ---

MOVIES AS PRAYERS OF RECONCILIATION

We'll never really know why Mookie threw the garbage can.

At the climax of *Do the Right Thing*, at the end of a blistering hot day in New York City's Bedford-Stuyvesant neighborhood, Mookie (Spike Lee) is closing up the family-owned pizza shop where he works. It's been a good day, says the owner Sal (Danny Aiello) to his two sons and Mookie. He's proud of them and makes a point to tell Mookie "you've always been like a son to me." When a group of teens starts banging on the door, demanding slices, Sal says to let them in. "They love my pizza."

Soon after, three other young men barge in, blasting Public Enemy's "Fight the Power" from a boom box and reiterating a demand they made of Sal earlier in the film: put some pictures of black people on the wall, not just Italian Americans. Tempers flash. Sal smashes the boom box with a bat. Radio Raheem (Bill Nunn) drags Sal out into the street and begins to throttle him. When the police arrive, they grab Radio Raheem, put him in a chokehold, and kill him.

The cops flee, leaving Sal and his sons standing in front of their pizza shop facing a crowd of Radio Raheem's family, friends, and neighbors. The temperature begins to rise again, until Mookie, of all people—small, sleepy-eyed, Sal's other "son"— picks up a trash can and hurls it through the shop's window, inciting an uprising that will leave Sal's Famous Pizzeria ravaged and burned.

FINDING A WAY FORWARD

There are times, as in *Do the Right Thing*, when the notion of reconciliation can seem not only impossible but also like another affront. When great injustice has occurred—whether it's the killing of Radio Raheem in the film, or Eric Garner, who died while in a police chokehold in 2014—righteous revenge, not reconciliation, feels more apt. And we must honor that urge. Before we pray for reconciliation, prayers of lament, anger, and genuine confession must be fully heard.

Yet remaining in alienation means death. Most of us have experienced this. Failing to reconcile can mean the death of community, as it does for Mookie's neighborhood, or the death of personal relationship, as it does for Mookie and Sal. Some of our lives are littered with people with whom we've been unable to reconcile, and who might as well be dead.

This is the connection between reconciliation and resurrection. Reconciliation is a deeply Christian idea because it is only made possible through the death and resurrection of Jesus. Paul explains it this way in Colossians 1:21-22: "Once you were alienated from God and were enemies in your minds because of your evil behavior. But now he has reconciled you by Christ's physical body through death to present you holy in his sight." We

only have life through Jesus' work on the cross; therefore, in gratitude, working toward reconciliation is the only way to live.

So how do we bring this about in our own lives? How do we not only forgive, which is hard enough, but also right those relationships that have gone wrong?

In my experience we pray, for reconciliation is impossible without the working of God. I know I'm not very good at it if left to my own devices, especially when I'm the one who's been hurt. I'd much rather just cut bait. Even after confession has been made, forgiveness has been granted, and restored relationship is desired, reconciliation is so antithetical to our sinful nature that it is downright miraculous when it occurs. And like most miracles, it is accompanied by prayer.

If prayers of anger and lament come easily—instinctively— prayers of reconciliation can be harder to muster. It can sometimes be difficult to even imagine what restored relationship might look like. In such times, I'm often surprised to find that the movies model it for me. The screen becomes a place for grace— for the sort of reconcili- ation that I, in my anger and lament, can't even fathom. Just when my own prayers stall, I witness the prayer of Mookie and Sal.

THE ART OF RECONCILIATION

We'll return to *Do the Right Thing*, but let's first consider how a few other films might function as prayers of reconciliation. To

be clear, I'm not simply in search of happy endings here. Often the sort of reconciliation offered to us just before the credits roll can be trite and cheap. Beware of Hollywood hugs.

Instead, I'm seeking moments that evoke one step in the long process of confession, forgiveness, and healing, ones that recognize what Emmanuel Katongole and Chris Rice describe in their book, *Reconciling All Things*: "Reconciliation is indeed an invitation into a journey. It is not a 'solution' or an end product, but a process and an ongoing search."[1]

The cinematic moments we'll explore, then, are not easy, happy endings, but rather hints that a journey of reconciliation is underway. Some of these take place within personal relationships; others speak to hope for restored relationship on a larger scale. All point to the "new creation" (2 Cor 5:17-19) that is yet to come, when we will finally, fully be reconciled with God. These are aspirational images of what reconciliation can look like. After witnessing relationship being restored, we can better imagine it. Imagining it, we can take it to God in prayer. And from there, the God of reconciliation can guide us in bringing it about in our own lives.

RECONCILING WITH OURSELVES

The Interrupters, a 2011 documentary from *Hoop Dreams* director Steve James, prays for reconciliation in a place that most of the world has given up on: Chicago's impoverished, crime-ridden neighborhoods. James's camera follows a handful of "violence interrupters" whose job it is to intervene in disputes before the arguments lead to bloodshed. Yet rather than simply police behavior, these interrupters have a more restorative goal: to convince the potentially violent "offenders" that they matter, that they're worthy of respect and love.

In the documentary we see the effectiveness of the program across various Chicago neighborhoods. Yet for all its expansiveness, the most powerful prayer of reconciliation in *The Interrupters* is an intimate one. Ameena Matthews—a former gang member herself and now a fiery, in-your-face interrupter—at one point confronts Caprysha Anderson, a teen girl who has been in and out of juvenile detention centers. Ameena has been working with Caprysha for months to get her life on track, only to discover that she hasn't been going to school as she had promised. As the two share a park bench, Ameena leans in close to Caprysha's ear to ask and answer two fundamental questions: "Do you want to be loved? *Absolutely*. Do you deserve to be loved? *Absolutely*."

Watch carefully and you'll notice something heartbreaking after Ameena's second question. Caprysha listens, head turned down, during the first question and answer. But between the second set she slips in a quiet "no." In Caprysha's mind there is a gulf between her desire to be loved and feeling as if she deserves it.

Establishing the fundamental worth of all involved—both offenders and offended—is not only good social work, it's also the very promise of the gospel. The questions Ameena asks are what God rhetorically asks of us. We absolutely want to be loved. In Christ, we absolutely deserve to be loved (Rom 5:10-11). For many of us, this is Reconciliation 101. Often the person we must reconcile with first is the one we face in the mirror.

MOTHER AND CHILD REUNIONS

Almost as intimate as the reconciliation that takes place within us is that which takes place between mother and child. I think of the hug—a good one—at the end of Spike Jonze's *Where the*

Wild Things Are, when runaway Max (Max Records), in his muddy wolf suit, returns home to a bowl of soup with his mom (Catherine Keener). She falls asleep while watching him, relieved but also exhausted at the thought of the hard work of reconciliation that lies ahead. And then there is Pixar's *Brave*, in which a daughter's defiance brings an ancient curse upon her mother, turning her into a bear. At the end of the film, having repaired the family tapestry that had been ripped during an earlier argument, Merida, the daughter, lays it over her furry mother like a blanket, embracing her beneath it and confessing, "I want you back, Mommy." Only then does a miracle occur.

These are both examples of reconciliatory endings, happy endings, as it were. Yet as I've mentioned, it's often the flickers of reconciliation that we see on screen—the little moments, like the one in *The Interrupters*—that better capture the prayerful, ongoing practice of reconciliation in our own lives. Reconciliation is rarely a completed act, after all; more often it's an active hope, something we continue to work at, little by little, each day.

This sort of hope drives the central character of *Beasts of the Southern Wild*, a six-year-old girl named Hushpuppy (Quvenzhané Wallis) who lives in a makeshift, off-the-grid Louisiana community with her father (Dwight Henry). Together, they scrape out a squalid existence, punctuated by celebrations of bayou independence with their equally impoverished neighbors.

In the background of *Beasts of the Southern Wild* is the breach between Hushpuppy and her mother. All we're told, in Hushpuppy's enigmatic voiceover, is that she "swam away." Did she abandon the family? Drown? We're not quite sure. At one point, spurred by her father's failing health, Hushpuppy and a handful of friends take to the water in search of her mother. Catching a

ride on a boat, they come to a floating bar. Partially sunk, it doesn't seem to hold much promise, for reconciliation or anything else. The sign on the door may say Elysian Fields, in reference to the mythical resting place for heroic souls, but beneath that is more ominous signage: "Girls. Girls. Girls."

Inside, however, the little girls find something strange and wondrous. Much of *Beasts of the Southern Wild*, directed by Benh Zeitlin, mixes social reality with fairy-tale fantasy, and this sequence is a particularly potent mixture of the two. A haze is in the air, the sort of stale smokiness that persists in grownup rooms without windows, yet through it we also see glittering, colored Christmas lights and walls covered with shimmering paper. There are "girls" (women), and they are courting men while wearing nothing but negligees, but they're also quick to hover over Hushpuppy and her friends as if the children were chicks and the women were hens.

Wandering about, Hushpuppy encounters the cook (Jovan Hathaway), who is preparing fried alligator tail—bits of flour catching the light as it floats in the air, just as it would when Hushpuppy's mother would make the same meal. The woman reminds Hushpuppy of the stories her father would tell about her mother: "She was so pretty, she never had to even turn on the stove. She'd just walk into the room and all the water starts to boil." Hushpuppy and this mystery woman share a meal of deep-fried gator, then join the others on the dance floor, where she holds Hushpuppy in her arms as they softly sway. She invites Hushpuppy to stay, but the girl declines. They share one last twirl, the cook disappears into the kitchen, and Hushpuppy heads home.

Was this woman her mother? Or did Hushpuppy just want her to be? Similarly, might the other women, in a reconciled world,

be mothers to the other girls? Like our prayers of reconciliation, *Beasts of the Southern Wild* exists in that hazy place of what is and what we hope will be. As we experience it here and now, reconciliation ebbs and flows. It stalls, then lurches forward. We can only pray for moments like Hushpuppy's dance, when we get a taste of what our relationships with God, with each other, and with the earth will one day be.

MARRIED, WITH COMPLICATIONS

Parent-child relationships often involve reconciliation, but Google the term "reconciliation movies" and you'll find that it mostly brings up films about another familial construct: marriage.

I've been married for a little over twenty years, and in that time, you better believe my wife and I have had to reconcile, repeatedly, over all sorts of things. Perhaps that makes it sound as if we've had a rough go compared to most couples, yet in a sense a marriage doesn't become a marriage until the partners have experienced brokenness of some kind and somehow been blessed enough to make it through to the other side.

At the start of the 1937 screwball comedy *The Awful Truth*, Lucy Warriner (Irene Dunne) and Jerry Warriner (Cary Grant) are as broken as a married couple can get, considering they're about to be divorced. Yet to see *The Awful Truth* as a comic prayer of reconciliation, don't focus on the plot, in which Jerry pursues a few ill-fated flings and Lucy reluctantly romances an Oklahoma oil man (Ralph Bellamy). Instead, pay attention to the secondary narrative going on between Lucy and Jerry, especially in the farcical scenes in which each tries to sabotage the romance of the other. Shared glances, inside jokes, instinctual smiles; no matter who they're supposed to be wooing,

Lucy and Jerry always seem to be the most compatible couple in the room.

There are even moments when they tiptoe around the idea of reconciliation, including a three-way conversation in which Bellamy's tycoon talks about winning dancing prizes back in Oklahoma. Lucy looks at Jerry and says, in an aside, "*We* never won any cups," more regret than accusation in her voice. "Maybe you had the wrong partner," Jerry replies, suggesting something of an apology.

The Awful Truth concludes in a lovely, extended sequence that is its own tentative prayer of reconciliation—not so much a happy ending as a signal that marital crisis has been momentarily averted. Having found themselves, via the convoluted plot, spending the night together in adjoining rooms at a house in the country, Lucy and Jerry discover that the door between them has a broken lock, so that it is easily blown open by the whims of the wind. (*The Awful Truth* doesn't allow for religion, but in this use of the wind, as well as the black cat that mischievously blocks the door shut at one point, the movie does make room for the supernatural.) When the door blows open after they've settled in, director Leo McCarey frames the shot from behind Lucy's bed, looking through the door to Jerry sitting in his bed. They are rooms apart, yet still together.

Notice also what they're wearing in this scene. Lucy has borrowed a baggy nightgown at least two sizes too big for her, so that she has to wrap it around herself like a blanket. Jerry has found a silly, striped sleeping shirt that makes him look like an oversized elf. "Air conditioning!" he jokes, swinging his bare legs in the air. They've spent most of the movie dressing fancily, not for their potential beaus but to provoke envy in each other. Here and now, they find themselves dressed only for humility.

After battling with the door a few times—while also dropping hints that they're grateful for this metaphysical intervention—Jerry notes to Lucy that at the stroke of midnight their divorce will officially go through. What follows is some classic, old-Hollywood wordplay. (Viña Delmar wrote the script, based on Arthur Richman's play.)

"Things could be the same if things were different," Lucy says, offering doublespeak that also has the faint air of hope.

Jerry confesses, "I've been a fool." And then, "So long as I'm different, don't you think that, well, maybe things could be the same again . . . only a little different now."

Topsy-turvy and delightfully delivered as this is, it's also the language of reconciliation. In Psalm 85, we're given a picture of restored relationship between God and his people. Tucked within it is this promise: "Love and faithfulness meet together; / righteousness and peace kiss each other" (Ps 85:10). *The Awful Truth* spares us the easy ending of a kiss—like so many movies of the 1930s, it's too sophisticated for that—but it does share Psalm 85's vision for a future in which those who were originally brought together in love will be in love once again.

THE BALLAD OF ALEXANDRA AND SIN-DEE

Reconciliation begins with recognition. Sometimes, it's a renewed recognition of the person we're married to, as happens with Lucy and Jerry Warriner. And sometimes it's the recognition of someone entirely new, someone who comes from a world vastly different than ours, in terms of race, class, gender, religion, sexual orientation, or otherwise.

These differences create gaps between us, and when those gaps are multiplied throughout society and exacerbated by fear,

they result in seemingly irreparable rifts in the social order (apartheid, redlining). Such rifts cry out for reconciliation, but where do we start? The parable of the good Samaritan (Lk 10:25-37) offers a simple suggestion: step out of your comfortable path and offer recognition to the other.

Growing up as a straight white boy in middle-class, cisgender suburbia, my own understanding of the experiences of those outside my traditional, privileged bubble came via two things. One was

Another way I "met" others who were very different from me was through the movies.

the church: shared worship services with African American congregations and service trips to unfamiliar communities offered windows into other worlds. Another way I "met" others who were very different from me was through the movies. Not that this was necessarily more comfortable than my church experiences. There was, for instance, the high school movie date I went on to a South Side Chicago theater to see Spike Lee's *Jungle Fever*, where my girlfriend (now wife) and I looked to be the only white people in the theater.

Despite the initial awkwardness, there was something beautifully illuminating about such movies (and experiences). I had grown up on Hollywood films that fantastically echoed my own life (*E.T. the Extra-Terrestrial*, *The Goonies*). I was now encountering pictures that forced me to recognize distinct others: the Bed-Stuy residents enduring police violence in *Do the Right Thing*; the suicidal, transgender hairdresser in *The Crying Game*;

the segregated families under South African apartheid in *Cry, the Beloved Country*. There was a big world out there, full of all sorts of people with all sorts of ways of living. The one thing we all seemed to share, if I was to understand the prayers these films were offering, was a yearning for reconciliation.

This is something the movies continue to remind me. In 2015 I slipped in a screener DVD of a little indie that had been getting good buzz: *Tangerine*, which follows a pair of transgender prostitutes on the streets of Hollywood over the course of a hectic Christmas Eve. Suffice it to say, not my scene. I finished the film stunned: by its bleary beauty (director-cinematographer Sean Baker and co-cinematographer Radium Cheung used a mobile phone that was adapted with a widescreen lens); by its frank depiction of the dispiriting realities of sex work; and by its persistent sense of grace. *Tangerine* gave recognition to its two "fringe" characters, and allowed me the chance to offer recognition of my own.

It's no coincidence, then, that tucked within *Tangerine* is a moving little prayer of reconciliation. For much of the film, we've followed Alexandra (Mya Taylor) and Sin-Dee (Kitana Kiki Rodriguez) as they try to track down Dinah (Mickey O'Hagan), Sin-Dee's rival for the romantic affections of their pimp. When they finally find Dinah, she's a mess, dazed and likely strung out. As Sin-Dee roughly drags her about the neighborhood—now in pursuit of the pimp—they take a break at a karaoke bar where Alexandra sings a slow, mournful version of "Toyland."

After the song, Sin-Dee drags Dinah to the bathroom, where you expect more abuse to take place. Yet something strange happens. Sin-Dee and Dinah's heated conversation drops from the soundtrack in favor of the movie's woozy, ambient score. Their mouths are moving, but we can't hear what they're saying.

As a disco ball sprinkles the dim room with tiny bursts of blue, Sin-Dee's anger seems to dissipate. Bringing their faces close together, she takes out her makeup and brushes a little color under Dinah's exhausted eyes. She adds a dash of lipstick, then turns her toward the mirror. They both look at each other and nod in recognition.

We must recognize before we can reconcile—especially in instances where we are too blinded by privilege, comfort, and tradition to even notice that reconciliation is needed.

Their recognition is, of course, different than mine. And their reconciliation, if it is to follow, is different than the sort that *Tangerine*'s prayer moves me to pursue. I come from a church tradition that has been in a decades-long struggle with issues regarding gender and sexual orientation, resulting in great division and pain. And despite continued conversation, reconciliation has been elusive. If a movie such as *Tangerine* might be too shocking for some in the church to consider, it might also be essential. We must recognize before we can reconcile—especially in instances where we are too blinded by privilege, comfort, and tradition to even notice that reconciliation is needed.

BACK TO BED-STUY

Despite its reputation as a rabble-rousing agitator, *Do the Right Thing* ultimately seeks reconciliation. The morning after Sal's shop has been reduced to skeletal embers, Mookie returns to demand his week's pay. Sal, sitting on the stoop, is initially incredulous, and for a second—in the umber light of Ernest R. Dickerson's cinematography—it seems as if more violence is at

hand. But the moment hangs in the air just long enough to dissipate. In a quieter voice, Sal asks Mookie the question a father would ask his son: "What are you going to do with yourself?" Mookie answers with the practicality he's shown all movie long: "Make that money. Get paid."

It is telling that *Do the Right Thing* ends not at the riot, with "Fight the Power" blasting in the background and a close-up of the pictures of Dr. Martin Luther King Jr. and Malcolm X that's tacked onto the shop's burned wall. Rather, the movie concludes with the relative peace of this morning after, and the hint of restored relationship between Mookie and Sal. As Mookie leaves, the camera pulls up and away to reveal everyday life resuming on the damaged block. On the soundtrack we hear Senior Love Daddy (Samuel L. Jackson), the local deejay, sharing the day's "cash money" word: "Chill." Could reconciliation be possible in this place, even after all we've seen? Believing so requires believing in a miracle, something like what Paul describes in Ephesians 2:14: "[Christ] himself is our peace, who has made the two groups one and has destroyed the barrier, the dividing wall of hostility." *Do the Right Thing* ends not in anger or with an easy answer, but with a Bed-Stuy spin on Paul's hopeful message, a prayer for the sort of reconciliation that can only be delivered by Christ's work, our willingness, and God's healing hands.

--- CHAPTER EIGHT ---

MOVIES AS PRAYERS OF OBEDIENCE

If he wasn't played by James Stewart, George Bailey would probably be insufferable. In 1946's *It's a Wonderful Life*, George has spent his entire life in Bedford Falls, New York, obediently doing the right thing, more often than not for the benefit of others. In particular, he repeatedly steps in to preserve his family's building-and-loan business, each time at the cost of delaying his own hopes and dreams. Yet in Stewart's portrayal, George is never self-pitying or saintly. He's simply a decent man who knows what's required of him, and he does it.

It's a Wonderful Life is now considered a Christmas classic, full of ringing bells and angels getting their wings. But if you settle in to watch it on a December evening, you might be surprised how out of sync much of it feels with the cheer and brightness of the season. The cinematography alone is so dark and shadowy in some sequences that you'd be forgiven for mistaking it for a piece of film noir. The weight of woeful American history—the Great Depression, World War II—looms in the

background of the narrative. Indeed, the movie opens by telling us that Stewart's decent George Bailey is so "discouraged" he's on the brink of suicide.

What has brought him to this point? On Christmas Eve, George's uncle misplaces a crucial bank deposit, without which the family business will collapse. Worn down by a life of covering for others, George no longer has the will or way to meet yet another challenge. Unless, that is, he makes a final sacrifice: killing himself so that his family will be saved by the life-insurance payout. And so, after getting drunk and crashing his car into a tree, George staggers to a bridge and looks into the black, turgid water. Leaping may preserve his family, yet you get the sense that for the resolutely dutiful George Bailey, it also seems like it would be an escape from the burden of obedience.

JONAH'S PRAYER

Remember Jonah, who made a similar leap into the belly of the whale? When we left the Old Testament prophet, he was rotting there in defiance, having refused to carry God's word of judgment to the Ninevites. Yet then, in Jonah 2, comes this resolute pledge of obedience, in the form of Jonah's prayer:

> You hurled me into the depths,
> into the very heart of the seas,
> and the currents swirled about me;
> all your waves and breakers
> swept over me.
> I said, "I have been banished
> from your sight;
> yet I will look again
> toward your holy temple."

The engulfing waters threatened me,
 the deep surrounded me;
 seaweed was wrapped around my head.
To the roots of the mountains I sank down;
 the earth beneath barred me in forever.
But you, LORD my God,
 brought my life up from the pit.

When my life was ebbing away,
 I remembered you, LORD,
and my prayer rose to you,
 to your holy temple.

Those who cling to worthless idols
 turn away from God's love for them.
But I, with shouts of grateful praise,
 will sacrifice to you.
What I have vowed I will make good.
 I will say, "Salvation comes from the LORD." (Jon 2:3-9)

Notice the path of this prayer, for it encapsulates a Christian understanding of obedience. When Jonah speaks of his decision to follow God's command, he describes it not as being restricted but rather as being rescued. After making his pledge to "look again toward your holy temple," he notes that God "brought my life up from the pit." Then, recommitted to the ways of the Lord, Jonah promises to obey not out of obligation or duty, but "with shouts of grateful praise." Here and elsewhere in the Bible, obedience to God is not a limiting of freedom but a flourishing of it.

The paradox at work here—the idea that freedom is found in obedience—is especially confusing to contemporary Western

ears. Post-Enlightenment, Americans in particular hold autonomy and individual choice in the highest regard. Of course distaste for obedience can be found as far back as the Garden of Eden. Although God set aside the tree of the knowledge of good and evil in order to protect Adam and Eve (Gen 2:17), they ignored that loving gesture and chose to exercise their freedom as we commonly understand it. Humankind has been obstinately exercising it ever since.

I remember a particular example of my own obstinacy. In 1991, the must-see movie was Jonathan Demme's serial-killer thriller *The Silence of the Lambs*, so I set out to see it with my eventual wife, then girlfriend, on another movie date. My parents happened to have caught the early show at the local multiplex, and we ran into them in the parking lot on our way into a later showing. Though they were liberal, if discerning, when it came to moviegoing, and had at this point largely left me to make my own viewing choices, something about *The Silence of the Lambs* particularly disturbed them. (I don't remember the specifics of their concerns.) And so they told us not to see the film. What did their son—a teenager eager to leave their particular Garden of Eden—decide? I pretended to obey by getting back in the car, but then drove around the parking lot, reparked, and marched right into the theater.

We survived *The Silence of the Lambs*; in fact today I think it's a rather brilliant, if troubling, movie. Yet whether or not my parents were "right," I understand their motivation. I may have felt restricted by their command, but they set this particular boundary out of love. To their minds, *The Silence of the Lambs* wasn't a movie that would enable my (or my future wife's) flourishing. Our loving heavenly Father feels the same when he sets

boundaries for us. And unlike those of us who are earthly parents, he has the omniscience to back up his boundary-marking.

And yet we keep circling the parking lot and going back into the theater, ignoring God's commands and deciding things for ourselves—which brings us to another characteristic of Christian obedience. In order to return us to the state of shalom for which we were created, but have since rejected, Christ has come. His work on the cross has paid the price for humankind's continual disobedience.

Our prayers of obedience, like Jonah's, are not only pathways to flourishing but also pledges of thankfulness and faith.

Christians obey, then, largely out of gratefulness for that saving, restorative act. Our prayers of obedience, like Jonah's, are not only pathways to flourishing but also pledges of thankfulness and faith.

THE ART OF OBEDIENCE

It's a Wonderful Life aside, the idea of pledging obedience goes against the ethos of so many movies, especially American ones, which tend to celebrate the triumph of the individual. For every *Citizen Kane*, a masterful depiction of the cost of "winning" the American dream, there are a hundred *Rocky*s (well, actually there are seven, and Rocky loses in the first film, but you get what I mean). There is a reason one of the most iconic and revered movie images is that of Sylvester Stallone's underdog boxer raising his fists at the top of those steps in Philadelphia. Indeed, is there anything more cinematically American than a training montage?

It's not only individualistic dramas that run counter to the idea of selfless obedience. Consider horror films, which depict diabolical acts that defy God's will for our lives. The dregs of the genre—like the run of "torture porn"[1] pictures that were popular in the 2000s, including the Hostel and Saw series—seemingly delight in depicting sadistic violence. What unites these films is not so much the suffering on display but the willful, gleeful disobedience behind it. They're a reminder of Lucifer's motto of self-determination in John Milton's *Paradise Lost*: "Better to reign in Hell than serve in Heaven!"[2]

Most horror movies, however, are built on an undergirding of morality, a recognition that such severe disobedience spreads nothing but pain and despair. Indeed, the most frightening ones, *Psycho, Night of the Living Dead, A Nightmare on Elm Street, 28 Days Later*, give us a taste of the terror of living in a world without laws of any kind. When Norman Bates (Anthony Perkins) murders Marion Crane (Janet Leigh) in the shower—as the stabs of Bernard Herrmann's score match George Tomasini's edits (cuts!)—*Psycho* breaks multiple societal rules all at once, including the Hollywood rule that the main character must live until the end of the film.

These are all negative examples, however, in which movies themselves either defiantly disobey or depict obeying as something to be done out of obligation and fear. What of a more biblical view of obedience? What of cinematic prayers that express the relief and comfort found in following God's law?

Let's look again at *Sunrise*, F. W. Murnau's silent melodrama about the adulterous husband who confesses in the very moment he is about to murder his wife. His confession comes fairly early on in the film, so that the middle section goes on to

chronicle his ensuing pledge of obedience, as he follows his wife into the city and tries to persuade her of his changed heart. It takes a while for the wife's fear to subside, but eventually she allows him to walk with her. They proceed to make their way through the busyness and chaos of the city, where he tentatively, gently woos her back with flowers and cake. Stopping at a church, they witness a wedding, which causes the husband to ask for forgiveness and tearfully renew his vows. Murnau stages the sequence as if the ceremony were for them, so that they emerge from the church just as bells are ringing. What follows is a second honeymoon in the city, as the husband and wife celebrate their reunion by having their photograph taken and dancing at a fair. Obedience here is not something the husband embraces in order to avoid punishment. Nor is it an act of begrudging duty, a willful resubmitting to marital chains. Rather, *Sunrise* depicts obedience as something exciting, fun, and even freeing.

There are other notable movie depictions of obedience as a liberating experience, including Robert Bresson's *A Man Escaped*, about a French Resistance fighter (François Leterrier) in a German prison camp. His dutiful commitment to demanding ritual—chiseling at his door with a spoon handle, creating a rope from strips of torn bedding—eventually leads to literal freedom. And there is 1940's *Pinocchio*, in which Pinocchio's own belly-of-the-whale experience leads away from the self-determination of Pleasure Island and back into flourishing freedom as Geppetto's son. Although these are wildly different characters in drastically different films, Pinocchio, the man escaped, and *Sunrise*'s husband all evidence positive obedience, that which feels like a blessing, not a burden.

"NO ONE CAN SERVE TWO MASTERS"

Prayers of obedience can also be heard throughout the various films in the ongoing, recently rejuvenated Star Wars saga. Growing up with the original movies as a kid, when I would argue with my neighborhood friends over who got to "play" Han Solo in our backyard reenactments, this connection wouldn't have occurred to me. Back then, spending time with Star Wars was time away from the things I *had* to do: school, church, piano lessons. Watching the films now, however, I see the concept of obedience as a through line. Consider, after all, how often the title "master" is used, whether it is uttered by a true Jedi knight or hissed by a devotee of the dark side. If the faithful fully submit to the ways of the mysterious Force that governs this fictional universe, then the disobedient try to use the Force for their own self-glorifying purposes. Yet as Jesus warned in Matthew 6:24, "No one can serve two masters."

We could chart this theme of obedience in narrative terms, tracing its arc through the details of Star Wars' vast, serialized plot. But more interesting and more cinematic are the *gestures* of allegiance that have come to define the franchise, the way some of its most memorable moments demonstrate obedience of one sort or another.

Consider, in the very first *Star Wars*, the way Obi-Wan Kenobi (Alec Guinness) uses his command of the Force to sneak fugitive droids R2-D2 and C-3PO past a handful of stormtroopers. With a gentle wave of his hand, he quietly tells them, "These aren't the droids you're looking for." And they obey. A more willing, and committed, expression of fealty can be found in *The Empire Strikes Back*, when Luke Skywalker (Mark Hamill) submits to an unlikely authority figure: big-eared, short-statured Yoda. As Yoda helps Luke better understand his inherited connection to the Force

during a period of intense training on the swampy planet of Dagobah, Luke marks his new devotion by often carrying the diminutive Yoda on his back, even in the midst of his exercises. *Return of the Jedi*—indeed, the original trilogy as a whole—coalesces in a climactic moment of *dis*-obedience, when Darth Vader (David Prowse) turns on his insidious master (Ian McDiarmid), hurling him into the abyss of the Death Star in order to save his son.

Gestures of obedience also mark the franchise's three prequels: the way Obi-Wan Kenobi (Ewan McGregor), Qui-Gon Jinn (Liam Neeson), and their foe Darth Maul (Ray Park) impatiently defer to intermittent, force-field panels during their climactic duel in *The Phantom Menace*; the secret clone army, aligned and awaiting its

In Star Wars, you are what you obey.

designers' bidding, in *Attack of the Clones*; Anakin Skywalker (Hayden Christensen) marking his commitment to the dark side by donning Vader's mask in the finale of *Revenge of the Sith*. Here, as in so much of the series, allegiance defines destiny. In Star Wars, you are what you obey.

This brings us to *Star Wars: The Force Awakens*, 2015's resuscitation of the saga. When the new hero Rey (Daisy Ridley) is imprisoned by the villainous Kylo Ren (Adam Driver), he attempts to read her mind using the Force. Rey, however, has recently discovered Jedi powers of her own. And so she is able to resist his attempted violation, demonstrating that forced obedience is no obedience at all.

Interestingly, Rey initially refused to acknowledge the power of the Force when she encountered it earlier in the film, after discovering the lightsaber that once belonged to Luke Skywalker. Her journey, then, is one in which she learns that submitting to the Force leads to flourishing. In both that mind-control showdown with Kylo Ren and a climactic lightsaber duel with him, it isn't until Rey closes her eyes and prayerfully steps outside of her own self that the Force fully flows through her. In following the Force, she is freed. In trying to bend the Force to his own will, Kylo Ren suffers.

Another fixture from my childhood, alongside Star Wars, was the 1887 hymn "Trust and Obey." (I'm sure I sung it at one point with a Han Solo action figure stuffed in my pocket.) The lyrics, written by John H. Sammis, include this couplet: "We never can prove the delights of His love / Until all on the altar we lay." Yes, obedience requires something that may feel restrictive at first. But if we can manage that, we'll find more freedom than we ever thought possible, in this or any other galaxy.

"IF YOU BUILD IT, HE WILL COME"

It is popular cinema's most familiar command, perhaps even more so than Charlton Heston's Moses demanding, "Let my people go!" Standing in his cornfield, surrounded by lush green leaves and the warm embrace of an early evening sun, Ray Kinsella (Kevin Costner) hears a whisper: "If you build it, he will come."

Field of Dreams, in which Iowa stands in for heaven, depicts one man's spiritual journey of prayerful obedience. Given a vision of a baseball diamond, Ray decides to build a full-scale field on his farm, complete with bleachers and lights. Doing so is a considerable sacrifice, considering corn could be grown on

the land, yet Ray obeys. "I have just created something totally illogical," he says, surveying the perfectly manicured grass and straight white lines with a grin. His neighbors aren't as amused, and their disdain is a reminder that Christian obedience often doesn't make sense to an outside world that operates on a different set of rules.

Eventually, someone does come: Shoeless Joe Jackson himself (Ray Liotta), along with a number of other players who were banned from baseball after being accused of throwing the 1919 World Series. Having been stuck in some sort of purgatory, they find freedom on Ray's field, able to play their beloved sport once again. Director Phil Alden Robinson lends a hushed holiness to these scenes, as the men reverently toss a ball back and forth under the soft glow of the field's lights, a deepening dusk rising from the surrounding cornfields. It's a magical moment. Even if you don't care a bit for baseball (and I gave up the game around age ten, when it consisted of long lonely stretches in right field and being beaned at the plate by errant, pip-squeak pitchers) *Field of Dreams* makes you feel what one character describes as "the thrill of the grass."

Later in the film, Ray receives other commands: "Ease his pain." "Go the distance." Following each one leads to a certain peace for others, as happened with Shoeless Joe, while Ray plays the part of accidental guru. As the bills pile up and the potential farmland remains unused, though, he begins to wonder if he should have left well enough alone—if it was worth putting his farm and family at risk. It comes to a boiling point when he asks Shoeless Joe if he can go with the players into the cornfield, to see what lies beyond, but is told that he's not invited. "I have done everything I've been asked to do," Ray responds in exasperation. "I didn't

understand it, but I've done it. Now, I haven't asked what's in it for me. . . . [But] what's in it for me?"

"Is that why you did this?" Joe responds. "For you?"

Obedience doesn't work like a rigged slot machine, though, where you put your acts of observance in and a reward comes spitting out. It is, instead, an expression of living within the reward you've already been freely given. In the Heidelberg Catechism, question 86 asks the same thing Ray does—"Why then should we do good works?"—and offers a four-part answer: "So that with our whole lives we may show that we are thankful to God for his benefits, so that he may be praised through us, so that we may be assured of our faith by its fruits, and so that by our godly living our neighbors may be won over to Christ."[3] By following the voice, building the field, welcoming the Black Sox, and enriching the lives of others, Ray Kinsella goes four for four.

BEASTS AND BURDENS

From the outside, from the back of a church, Christian obedience can look like a huddled mass shuffling mindlessly in the same direction. Heads down, shoulders hunched. Maybe even going in circles. This may sound unflattering, but it's also how you could describe the noble birds of *March of the Penguins*, a 2005 nature documentary that records the astonishing acts of commitment and endurance emperor penguins perform in order to ensure the survival of the next generation.

Seeking thick ice that won't shift or break, the birds waddle seventy miles from the ocean to their breeding grounds at the end of each summer. Once the eggs are delivered, the mothers transfer them to the fathers, who will balance them on their claws for more than four months while the mothers return to

the sea for food. The parents will then take turns holding the eggs and hunting. Those left behind on the ice form a black throng, continually moving, in order to survive the far-below-zero temperatures.

There is always an element of sacrifice to obedience. Mostly it is a "sacrifice" of the things we think we need but really just want. Occasionally it's an actual sacrifice of genuine goodness, as the penguins do when they go without food. (The human parenting equivalent of this, at least in my experience: sleep.) The Bible may promise that such obedience leads to joyful flourishing, but it never tells us that the process will be quick. Sometimes our winters are long. When Jesus told his disciples, "Whoever wants to save their life will lose it, but whoever loses their life for me will find it," he offered both an assurance and warning (Mt 16:25).

Still, God keeps his promises. And as Morgan Freeman, the narrator of *March of the Penguins* and frequent cinematic stand-in for God, declares at the start: "This is a story about love." To witness the joyful flourishing that follows prayerful obedience in the documentary, watch the chicks. Peeking from beneath their parents'

To witness the joyful flourishing that follows prayerful obedience in the documentary, watch the chicks.

feathers, adding squeaks to the more mature calls surrounding them, their new life is a fuzzy retort to a habitat defined by death. The camera is mostly static throughout *March of the Penguins*, as the filmmakers try to remain as unobtrusive as possible, but at one point it indulges in a tracking shot to trace a little chick's first

scooting steps across the ice. The effect is electric. We're witnessing gleeful independence within foundational boundaries. (Remember the thick ice beneath its feet?) This could be described as a circumscribed freedom. These babies' wobbly waddling—and their parents' obedient marching—are both reminiscent of David's pledge to "walk before God" in Psalm 56:12-13:

> I am under vows to you, my God;
> I will present my thank offerings to you.
> For you have delivered me from death
> and my feet from stumbling,
> that I may walk before God
> in the light of life.

Obedience seems to come somewhat naturally for penguins. No so much with stallions. *The Black Stallion* is an adaptation of the 1941 children's novel by Walter Farley, which traces a horse's journey from abusive restraint to unlimited freedom to true flourishing. The movie opens on a ship off the coast of North Africa, where a young boy (Kelly Reno), who is traveling with his father, witnesses a powerful horse being subdued on the deck. The poor beast is blindfolded, while multiple men try to hold him down with ropes. When these fail to stop his rearing and kicking, he's whipped. It's a jarring vision of disobedience and subjugation.

Later, the boy peeks into the stall where the stallion is restrained and leaves him a few sugar cubes. This is the beginning of a bond that will blossom after a shipwreck leaves the boy and the horse as the only survivors on a wild and deserted island. On shore, the stallion's ropes have gotten caught among rocks, pinning him down. The boy cuts him loose, and the magnificent creature runs free. This island section is pure cinema, as director

Carroll Ballard relies less on words than on Caleb Deschanel's ravishing cinematography to tell the story. The first time the scrawny boy feeds the horse, the moment is captured in silhouette against a shimmering sea, their tentative gestures taking on the form of a beautiful dance. The two eventually embrace their predicament as something of an idyll—a paradise without parents or masters of any kind. Certainly there are no rules.

Yet there is a serpent in this garden, a venomous cobra that slithers up near the boy as he sleeps. And although the stallion saves him by suddenly trampling the deadly creature, it is a sign that their freedom is a deception. On this island, they are at once completely free and hopelessly trapped. They're masters of their own fate, yet endangered and doomed.

A different sort of freedom is found in the movie's second half, after the boy, named Alec, and the horse, now called the Black, are rescued and welcomed home as celebrities. They meet a retired jockey (Mickey Rooney) who offers to train the horse and show Alec how to ride. This leads to a climactic race in which the Black takes on the top horses of the nation. Alec and the Black get off to a rough start, but by the final length they manage to recapture the best of their time on the island—a purity in form and purpose that is visually referenced in elegant flashback snippets—and win.

Some might argue that horseracing, even under a kind owner, is hardly flourishing for an animal, and I'm sympathetic to that opinion. But I'm also willing to take much from a tiny detail in the final moments of the film, when Alec is quick to remove the Black's heavy bridle in the winner's circle, allowing him to freely shake his mane. As a parable of prayerful obedience, then, *The Black Stallion* echoes these words from Baylor University theology professor Roger Olson: "Only when obedience is joyful,

when it stems from gratitude, does it result in true freedom, in the freedom of being who and what we are meant to be."[4] In the context of the movie's narrative, the Black flourishes not under the abusive whip of his former owner or even amid the wildness of the island. Rather, he finds himself under the gentle reins of Alec, a loving master whose yoke is easy and whose burden is light.

CLARENCE EARNS HIS WINGS

Remember George Bailey on the bridge in *It's a Wonderful Life*? Just as he is about to jump, he hears a splash. Another man has fallen in, and is crying for help from below. George's sacrificial instincts kick in, and he leaps in the water to save the man, forgetting all about his suicidal plans.

We already know, from the movie's heavenly opening, that this man is Clarence (Henry Travers), George's guardian angel. He tells George, "I'm the answer to your prayer," and proceeds to take him on an alternate-reality journey through Bedford Falls to see what it would be like if George had never been born. Without George to honestly run the family's building-and-loan company, a parasitic businessman (Lionel Barrymore) has filled the void and turned Bedford Falls into a seedy tenement town. What's more, George is no longer recognized by his friends, his neighbors, or the woman who was his wife (Donna Reed). Indeed, his children don't even exist. "You have no identity," Clarence tells him. In this alternate reality, which is missing George Bailey's sacrificial faithfulness, Bedford Falls is a far darker place and George is a cipher—a far cry from the man he was created to be.

Like Scrooge in Dickens's *A Christmas Carol*, George seeks to be delivered from his tormenting reverie, to return to his life with a deeper understanding of its purpose. Running back to the bridge,

blinking into the falling snow, George repeatedly begs, "I want to live again . . . I want to live again." His prayer is answered when the local cop (Ward Bond) recognizes him. George then realizes that he's returned to his former life. He runs through town shouting "Merry Christmas!" to everyone he sees and rushes into his "wonderful old drafty house" to embrace his family and face the bank authorities over that missing deposit. "You see George, you really had a wonderful life," Clarence observes. The implication being, of course, that George's devotion was part of—indeed, crucial to— much of that wonderfulness. In returning to it rather than escaping from it, in refusing to take that selfish leap to "freedom," George Bailey truly becomes free.

--- CHAPTER NINE ---

MOVIES AS PRAYERS OF
MEDITATION AND CONTEMPLATION

Can you picture the face of silent-film comedian Buster Keaton? The big eyes. The slightly downturned mouth. The long nose. Onscreen, Keaton rarely smiled. His stoic, deadpan expression earned him the nickname the "Great Stone Face." Another way to describe his demeanor, however, would be to say that he was paradoxically calm. In the midst of the frantic silliness surrounding him, Keaton would carve out a contemplative center. His comedy was at once chaotic and meditative.

In 1928's *Steamboat Bill, Jr.*, Keaton performs one of his wildest comic stunts without moving an inch. When a windstorm hits the river town where the story is set, Keaton and director Charles Reisner pull out all the stops: pedestrians are flipped head over heels, unattended vehicles go barreling down the road, and roofs fly off the buildings. Keaton's title character is in the hospital, hiding under the sheets of his bed, when all

four walls of the edifice get sucked up into the sky, leaving him exposed. His bed is subsequently blown down the street, eventually stopping in front of a house whose façade is perilously cracking and threatening to fall forward. Keaton stands up, collected but confused, as the giant wall teeters toward him and breaks free, veering down. He's spared only because he happens to be standing exactly where the frame of an open window falls.

It's Keaton's reaction that sells the gag, and the reason he was such a distinctive star. There is no jump of surprise or cry of alarm when the building crashes around him, only a slight nod of the head and a curious look around. After a pause, he flees the scene, stopping a few times to turn and look back at the house, mildly perplexed at what has just occurred. Of everyone flailing about the town, Keaton seems to be the only one who is both enduring the storm and contemplating it.

We were created with the urge to contemplate, to shut out the realities of the moment—as pressing as they may feel—and attend to something larger.

TAKE A DEEP BREATH

In our frantic, hectic, and distracted modern world, meditative and contemplative prayer may be the most difficult form of prayer to practice. We'd much rather mutter a quick word or two to God while stuck in traffic; that's not only spiritual but also efficient. Such multitasking stands up well to a careful, cost-benefit analysis. Yet unlikely as it may seem, we were created with the

urge to contemplate, to shut out the realities of the moment—as pressing as they may feel—and attend to something larger.

Most discussions of Christian meditation begin with nervous assurances of what it is not: Buddhist, New Age or—most terrifying of all—yoga! More important than what Christian meditation is *not*, however, may be what it *is*: biblical. In reference to his law, God tells Joshua to "meditate on it day and night," a command that was also followed by the psalmists (Josh 1:8; Ps 1:2; 119:97). Christ's time in the wilderness was a time of meditation, albeit one interrupted by a devilish tempter (Mt 4:1-11). His prayer in Gethsemane was a pained attempt to ruminate on and understand the will of the Father (Mt 26:36-46). In 1 Corinthians 2, Paul writes of contemplating the mysteries of God as an act that is Spirit-led: "These are the things God has revealed to us by his Spirit. The Spirit searches all things, even the deep things of God" (1 Cor 2:10).

Two things stand out from these biblical examples: meditative prayer is directed by the Holy Spirit, and it is focused on the nature of God as revealed in Scripture. Christian meditation, then, is a search for wisdom, not an escape from reality. Christian contemplation is an experience of God, not a burrowing into self or an attempt, as the narrator says on a yoga DVD I've used, to "melt into timelessness."[1] (The routine is relaxing, but I've yet to melt.)

One thing that yoga gets right, however, is that there is a connective tissue among the physical things that surround us and the metaphysical presence that sustains us. Christians are just more specific about who that presence is and where he can be found. My attempts at meditative and contemplative prayer haven't been very successful; it would take years of practice to corral this scattered brain. Yet the times I've been able to notice,

really *notice*, God's clear listening presence are those that began with his Word. (I'd suggest *Seeking God's Face: Praying with the Bible through the Year* as a beginner's guidebook.)[2] Scripture, as in many things, keeps our meditation and contemplation honest.

This isn't to say that Christian contemplation always means following a restrictive road map. Rather, it recognizes that even as God's presence surrounds us, it also refuses borders. In *Close to the Heart: A Guide to Personal Prayer*, Margaret Silf says this of contemplative prayer:

> In your own home, prayer awaits you in the opening of a flower, the rising of your bread dough, or the steady, imperceptible development of a child. Spend time in silence, aware of the wonder that is being unfolded in your cakes and your children, your houseplants or your garden. For this is the essence of contemplative prayer—simple *awareness*, allowing God to be God, without trying to put the limitations of shape or meaning around him.[3]

You know how this goes by now. If flowers and dough can be a pathway to contemplative prayer, why not film?

THE ART OF MEDITATION AND CONTEMPLATION

My personal, limited experience of contemplative prayer has mostly taken place amid nature. And it doesn't have to be A-list nature. Sure, I've been wowed by the carved depths of the Grand Canyon and the reaching range of the Smoky Mountains, but as a Midwesterner, more often than not it's the long, low stretch of a prairie or the sudden appearance of a quiet pond that stills me. On a recent winter walk through one such place, where the woods opened up onto the white expanse of a snow-covered

slough and hardy birds persisted among bare branches, every-thing around me seemed to calm and center. With Scripture leading my thoughts ("Look at the birds of the air" [Mt 6:26]), a quiet overcame me, a serenity that said, "God is in this place."

In "Lines written a few miles above Tintern Abbey," English Romantic poet William Wordsworth doesn't find God (indeed, he calls himself a "worshipper of Nature"), but he does describe a somewhat similar experience. For Wordsworth, remembrance of a moving pastoral scene leads to a unique state of tranquility:

> Though absent long,
> These forms of beauty have not been to me,
> As is a landscape to a blind man's eye:
> But oft, in lonely rooms, and mid the din
> Of towns and cities, I have owed to them,
> In hours of weariness, sensations sweet,
> Felt in the blood, and felt along the heart,
> And passing even into my purer mind
> With tranquil restoration.[4]

For Wordsworth, such meditation allows us, as he says later in the poem, to "see into the life of things." A Christian might say that through prayerful meditation we can see into the life of Jesus. Moving from poetry to film, it's worth noting there are movies that directly meditate on the nature of Christ: Carl Dreyer's *Ordet*, Robert Bresson's *Diary of a Country Priest*, and Martin Scorsese's *The Last Temptation of Christ*, to name a few. And they all have truly meditative moments. (I think of Scorsese's Jesus, played by Willem Dafoe, drawing a circle around himself in the dust of the desert, where he will remain in contemplation.) But what of those movies that function in the

manner of Wordsworth's "Tintern Abbey"? What of those that model a communion with God even if they do not mention him?

I experienced something similar to my winter walk when I first watched *Leviathan*, an experimental 2013 documentary in which dozens of tiny cameras are stuck into the various nooks and crannies of a commercial fishing vessel. With no narration to fill in the gaps, the resulting imagery is vaguely familiar, but mostly abstract and surreal. Once I aligned my breathing with the movie's rhythm—which was set by the rushing of water, the cranking of gears, and the clanking of chains—the seemingly mundane and monotonous took on a new significance. A shot of seagulls floating alongside the ship at night, their flaps of white pulsing like persistent heartbeats in the darkness, became transcendent. Like the birds in my Midwestern woods, which clung to dead branches that still held the promise of new life, these seagulls shimmered with a resonant hope. Even amidst the cranking, bewildering, manmade chaos of that fishing trawler, God was there.

I've been using the terms *meditation* and *contemplation* interchangeably, but there is a distinction, perhaps best described by the sixteenth-century mystic Saint John of the Cross: "The difference between these two conditions of the soul is like the difference between working, and enjoyment of the fruit of our work; between receiving a gift, and profiting by it; between the toil of travelling and the rest of our journey's end; between the preparation of our food and the eating and enjoyment of it."[5]

The films to follow have been arranged in this way. The first few could be described as movies of prayerful meditation: those whose form and function encourage our minds to study and wonder. Following that are movies that more closely resemble prayerful contemplation: an intense experience of God,

something similar to the way we can experience him, as Margaret Silf suggests, in the rising of dough or the opening of a flower.

MEDITATION AT 5 MPH

How about in the rolling along of a riding lawn mower? *The Straight Story* is a movie about an unusual journey, but mostly it's a movie about sitting in stillness. Director David Lynch, in a departure from the psychological surrealism that is his specialty (*Eraserhead, Blue Velvet, Mulholland Drive*), here turns his camera on the true-life, G-rated tale of Alvin Straight, an elderly Iowa man who drove a riding lawn mower 240 miles to visit his ailing, estranged brother in Wisconsin.

Alvin (Richard Farnsworth) is a meditative man. He lives with his grown daughter Rose (Sissy Spacek) in a humble home where they share many moments of quiet contemplation—gazing at the stars, watching a lightning storm, or listening to the rumble of the nearby grain elevator. Once Alvin embarks on his journey, depicted by Lynch with recurring images of long country roads and the slow spinning of the mower's 5 mph wheels, he assumes a monk-like routine of riding and resting. There is purity to this pattern. Even after he pulls off the road for the night or to seek shelter from rain, Alvin doesn't immediately distract himself with something to pass the time—say, a mobile phone or a book. No, he just sits. (Well, okay, he does light one of his ever-present Swisher Sweets.)

There is another quality to Alvin's practice that's worth noting: it makes room for others and, in fact, encourages a certain meditative posture on their part. From the runaway teenager who shares his fire one night to the bicycle racing community that welcomes him into their camp to the fellow vet who trades war

stories with him, each, in Alvin's presence, takes time apart from the pattern of their lives to sit with their thoughts. (Notice Alvin has brought along an extra chair in his trailer.) And Alvin, a man whose own sitting has led to certain wisdom, offers them a folksy form of guidance. "I've seen about all that life has to dish out," he tells the cyclists. "I know to separate the wheat from the chaff, and let the small stuff fall away."

Alvin reminds us, then, that the goal of meditative prayer is not to shut out the world. In fact, twentieth-century Christian mystic Thomas Merton would suggest the opposite: "For the monk searches not only his own heart: he plunges deep into the heart of that world of which he remains a part although he seems to have 'left' it. In reality the monk abandons the world only in order to listen more intently to the deepest and most neglected voices that proceed from its inner depth."[6] This is what makes Christian meditation distinctive. It is not a retreat, an escape from the realities of the brokenness around us. Instead, it is a pause inward, in order to move outward—a considering of others and a communing with God in order to better serve the world.

Indeed Alvin, a taciturn man who mostly keeps to himself, has been deeply searching and listening for decades. Talking to that fellow World War II veteran and recalling his time in France as a sniper, Alvin makes an observation that would also apply to the meditative life he has settled into: "It's an amazing thing what you can see when you're sittin'."

"MEDITATE ON IT DAY AND NIGHT"

Whereas *The Straight Story*'s meditation is largely secular, *The Decalogue*'s is blatantly founded in the Bible. In fact, there is perhaps no more intense and exhaustive cinematic meditation on

God's law than director Krzysztof Kieslowski's ten-part series of short films, each loosely based on one of the Ten Commandments. The installments, which originally appeared on Polish television in 1989 and received a prestigious Criterion Collection release in 2016, consider the commands from an oblique angle: not every short clearly relates to a corresponding commandment of the Bible (Ex 20:1-17), while religion itself is often a side note or not present at all. Along with Elijah Davidson, codirector of Fuller Theological Seminary's Reel Spirituality, I led an online discussion of *The Decalogue* to celebrate its twenty-fifth anniversary. We turned ourselves into knots debating the particular significance of Kieslowski's take on the biblical law. Clearly percolating underneath each short film, however, is a curiosity about what the Ten Commandments might still mean for a cross-section of residents living in a Warsaw apartment complex.

In *Decalogue I*, belief in technology curdles into idolatry. Krzysztof (Henryk Baranowski) puts his faith in the computers that dominate the apartment he shares with his young son (Wojciech Klata). But he learns, tragically, that logic has its limits. In *Decalogue V*, the Mosaic prohibition of murder is considered alongside the contemporary reality of capital punishment. At the execution of a convicted killer (Miroslaw Baka), procedural "justice" gives way to frantic chaos, and shame fills the room like a noxious gas. In *Decalogue IX*, covetousness contributes to the tension between a struggling husband and wife (Piotr Machalica and Ewa Blaszczyk). Their growing separation is underscored by an ingenious shot in an open elevator, where the light cast by each passing floor alternately illuminates her, then him, but never both at once. In these meditations and the seven others that make up *The Decalogue*, the

biblical commandments leap from Moses' tablets of stone and land in the messiness of everyday, modern life.

The Decalogue, as you can see, is not merely a dramatic reiteration of dos and don'ts—Moses updated for the modern age. Nor is it a threat, a finger-wagging exercise meant to scare us into obedience. (Remember, fire-and-brimstone threats fall on deaf, modern ears.) Instead, these short films marinate in the Ten Commandments so that we can meditate on their implications: Why were these laws given? What does life look like when they aren't followed? And in the face of our inability to keep them, where do we turn?

CONTEMPLATING THE "BORING"

The Decalogue doesn't fully answer all of those questions, which is a reminder that meditative prayer, too, does not lead to full understanding. It is no key to the universe. Even Julian of Norwich, one of the major figures in the Christian mystic tradition, acknowledged that "the more we busy ourselves to know God's secrets, the further away from knowledge we shall be."[7]

When we reach this point—when we've meditated on Scripture but still run up against the mystery of God—we must surrender to the art of contemplative prayer. Here, meaning and purpose are relinquished. Emptiness is accepted. Experience is open-ended. For those, like me, whose faith feels firmer when it clings to some semblance of rationality and reason, embracing the act of contemplative prayer can be an unsettling prospect.

There is a particular kind of cinema that models prayerful contemplation, however, and has helped me understand how such prayers might work. I like to call these body-rhythm movies. If you surrender to them and their lack of a clear narrative imperative,

you may notice your heart rate slowing to match the movement or sounds on the screen. Your mind drifts away from practical concerns having to do with character or plot, and lingers on things such as light and color. This was my *Leviathan* experience; though a dull slog for many who expected a story or narration to help orient what they were seeing, I'd describe it as sublime.

Experimental cinema, to which *Leviathan* somewhat belongs, often functions this way. Yet contemplative movies don't always have to be so blatantly abstract. If someone describes a film they've seen as "boring," "pointless," or "monotonous," take note: they could inadvertently be alerting you to a wonderfully contemplative experience.

Once Upon a Time in Anatolia is a two-hour-and-thirty-seven-minute Turkish film that devotes a good chunk of its running time to a line of police cars traveling along a rural road. The motorcade is in search of a murder victim's body, but the movie isn't really about whether or not they find it. For these long, contemplative moments, at least, it's about the way the beams from the cars' headlights float along the curving path of the road, inducing a mesmerized state in the willing viewer. The American independent film *Upstream Color* works similarly: its bizarre plot involving hypnotic drugs, Thoreau's *Walden*, and pig surgery is less important than the way scenes and lines of dialogue loop around themselves, much like a repetitive prayer. Even a movie with a clearer surface story, such as Paul Thomas Anderson's *The Master*, lingers in my memory not for its tale of Freddie Quell (Joaquin Phoenix), a troubled World War II veteran struggling to assimilate into civilian life, but for its contemplative digressions. At one point, while Freddie is out in the desert testing a motorcycle with the self-help guru (Philip

Seymour Hoffman) who has taken him under his wing, he's told to pick a point in the distance and race toward it as fast as he can. Freddie does so with fanatical devotion. As he fades further and further into the horizon, far further than expected, we're left to sit in silence and mystery. Freddie Quell has abandoned us to contemplation—in the ascetic landscape of Christianity's "desert fathers," no less.

Of course, there are thematic and even narrative implications to these moments that I'm describing. Critics earn their keep teasing such things out (though if you run into an *Upstream Color* enthusiast eager to explain it, find yourself a comfortable seat). But sometimes the beauty of watching a movie is in the enigma of the experience. This is also the beauty of contemplative prayer. "The contemplative is one who would rather not know than know,"

Sometimes the beauty of watching a movie is in the enigma of the experience. This is also the beauty of contemplative prayer.

wrote Thomas Merton, echoing Julian of Norwich's attitude toward empirical knowledge. "Only when we are able to 'let go' of everything within us, all desire to see, to know, to taste and to experience the presence of God, do we truly become able to experience that presence with the overwhelming conviction and reality that revolutionize our entire inner life."[8]

I wish I could say I've experienced that overwhelming conviction as part of contemplative prayer, but this doesn't come easily for someone whose faith has been largely defined by intellectual Protestantism. Those of us who like to mix reason and

religion don't exactly "let go." I'm grateful for a film like *Leviathan*, then, which would rather its audience "not know than know." The movie is an act of mysticism, one that models and encourages a contemplative way.

THE SOUNDS OF SILENCE

To aid their own contemplation, early Christian mystics would often take things away—by fasting, say, or removing themselves from the busyness of society to live in the desert. Similarly, many movies encourage contemplation by removing one of the basic elements of cinema: sound.

We underestimate the power that sound has over the film-watching experience. True, much attention is given to film scores, especially if they employ a memorable musical theme. If I mentioned *Star Wars* or *Jaws* or *Raiders of the Lost Ark*, there's a good chance that a John Williams motif came to your mind even before the face of Harrison Ford or Darth Vader. This is why many silent films, whose overtaxed scores carry the burden of communicating plot and expression along with mood, can seem as audibly busy as contemporary "talkies." Not even Buster Keaton was truly silent.

Yet even films with modest or no traditional musical scores use sound extensively. Sometimes their use of it is paramount to what the movie is trying to achieve. I think of the "found footage" horror landmark *The Blair Witch Project*, which purported to consist of video left behind by student filmmakers who disappeared in the woods. Long stretches consist of a black screen and sparse, frantic, muffled audio. Who knew you could jump so high in your seat at the unexpected crack of a snapped twig?

Often we don't realize the power of sound in cinema until it's completely taken away. One of the films that comes closest to doing this, and sustains the conceit for a good twenty-four minutes, is 1955's *Rififi*, directed by Jules Dassin. A French crime drama, the movie's centerpiece sequence is the elaborate heist of a jewelry store, which four burglars break into through the ceiling of the above apartment.

As the thieves enter the dark apartment and the music fades away, our eyes and ears instantly come to attention: we're going to need them more than usual. As the camera pans the room following a flashlight beam, we both peer and listen more closely. We watch the hand signals given and try to interpret the meaning of the low, occasional whistles the thieves share, trying to follow their plan. When one of the suitcases they've brought is finally opened, we greedily zero in on what's inside—slippers! So they will make even less noise.

From there, *Rififi* settles into quiet contemplation of the process of the heist: the careful laying out of the tools needed; the chiseling through the floor, muffled by cloths. One of the thieves has devised a genius idea: once a hole in the floor/ceiling has been made, an umbrella is slipped into the store below and opened from the apartment above. Why? To softly catch the falling debris so it doesn't crash to the store's floor, giving them away.

Time continues to pass, both too slowly and too quickly, as the thieves are under a strict deadline and every second is a risk. When one of them accidentally hits a key on the piano in the apartment, the others pause and dramatically frown. The sound disrupts what has become a holy place.

Indeed, as the heist proceeds, it takes on a liturgical structure, albeit one fixed around a decidedly worldly object of devotion. In

The Way of Perfection, Saint Teresa of Ávila discusses the Prayer of Quiet, which she describes as "the beginning of pure contemplation."[9] When *Rififi's* thieves are finally gathered around the jewelry store's safe, they adopt a prayerful posture. A circular tool rhythmically scrapes the back of the safe, inching its way inside. With each metallic squeak, the camera shifts to a different expectant face. In Teresa's terms, "All the faculties are stilled."[10]

Do they get away? And if they do, does their immoral "victory" negate my use of the film as a parallel to prayer? I'll leave you to watch *Rififi* and determine the answers yourself.

"ALL WILL BE WELL"

Some thirteen years before *Rififi*, a very different movie also made extensive use of quietness: Disney's *Bambi*. There is a sequence in *Bambi* when you're suddenly no longer in an animated children's film. In fact, you're no longer in a movie at all, but in a place that more closely resembles Wordsworth's hushed woods.

Bambi is resting with his mother among some brambles when he notices a drop of rain splash onto a nearby leaf. More drops fall, matched with musical plinks on the soundtrack, until a trickling stream gathers, which the camera follows with a musical lilt. Add the realism of the animation, and we hardly notice that human voices have begun to sing: "Drip, drip, drop / Little April shower / What can compare with your beautiful sound."

Then the storm arrives. Cymbal crashes accentuate lightning flashes, while the human chorus abandons words to create a moaning, whirling aural vortex. Bambi shudders and the other animals huddle; there's a quick but lovely shot of a hummingbird perched under the curved roof of a jack-in-the-pulpit flower. A family of rabbits, their ears alert, peeks out from a warren. An

ornery owl, woken by the tumult, frowns and turns its back on the rain in disapproval.

Eventually, the storm subsides and the sun begins to leak through the dissipating clouds. The voices fade as stillness descends on the woods, leaving Bambi and his mother in hushed contemplation. When the final, light plink of rain drips into a puddle, rippling the reflected sky within, *Bambi* is no longer a movie. It's an echo of Julian of Norwich's most well-known encouragement, drawn from her own contemplation: "All will be well, and all will be well, and every manner of thing will be well."[11] Bambi's contemplation is fleeting; we all know what is to come for him. Yet for this moment, peace and quiet has been found.

EYE OF THE STORM

All is usually well by the end of a Buster Keaton film—against all odds. That storm sequence in *Steamboat Bill, Jr.* concludes with Buster making four unlikely river rescues, never once cracking a smile. In another Keaton classic, *Sherlock, Jr.*, he brings his meditative calm to a car chase, in which he and the heroine (Kathryn McGuire) are fleeing a pack of goons. Unable to stop at the edge of a lake, Buster's convertible goes flying into the water. After a moment of consideration, he lifts the top halfway up to create a sail. As the wind catches it and carries them along, Buster puts his arm around McGuire and contemplates the view. Without too much trouble, he's turned a car chase into a romantic gondola ride.

Prayerful contemplation is a matter of shifting our perspective, of finding an unlikely way to keep our wants and needs at bay, as pressing as they might seem. We think we're in a sinking car, but contemplation can reveal a gondola.

I suppose this is another way Christian meditation differs from yoga: it's not a regimen but rather an experience that is out of our hands. Here is more pastoral, *Bambi*-like imagery, from Margaret Silf: "We can open our hearts to it by the practice of awareness, but we cannot bring it about, any more than we can force a flower to open or an egg to hatch. And in our silent, trustful waiting, we are acknowledging that God is God, the source and the destination, the means and the end of all our prayer, whatever form it may take."[12] When it comes to prayerful meditation and contemplation, perhaps a deep, abiding faith and the stillness of Buster Keaton is all that we need to bring.

--- CHAPTER TEN ---

MOVIES AS PRAYERS OF JOY

Most Fred Astaire and Ginger Rogers musicals spend some time establishing their flimsy plot before the dancing begins, and I'm usually a bit fidgety as I wait for the first production number to arrive. In *Top Hat*, Astaire seems to feel the same way. As he and Edward Everett Horton are cheerily trading narrative exposition—Astaire plays American dancer Jerry Travers, Horton is his producer friend, and they've met at a London hotel to prepare for an upcoming show—Astaire smoothly slips into a song and a shuffle to the tune of Irving Berlin's "No Strings (I'm Fancy Free)." His enthusiasm grows as he spins past a counter and taps out the rhythm. When the phone rings, he escorts Horton to answer it with a little strut. He has a joy that can't be contained.

Indeed, Astaire keeps dancing, even after Horton leaves the room. (After all, he's not dancing for Horton, but for us.) Less appreciative of the performance is Rogers's Dale Tremont, a model who is staying in the hotel room below his and can't sleep with all of that tapping going on. She knocks on his door to

complain, and he opens it with a blissful smile. "I'm so sorry, I didn't realize I was disturbing you," he says. "You see every once in a while I suddenly find myself . . . dancing."

"Oh, I suppose it's some kind of affliction," she blithely responds. Astaire pursues her into the hallway, where he melodramatically claims, "I think I feel an attack coming on." When he has these dancing fits, he suggestively tells her, his nurses usually put their arms around him. Rogers scoffs and heads back to her room. But she'll come around.

THE ESCHATOLOGY OF JOY

We sometimes say that birds dance. A male red-capped manakin even performs a variation on the moonwalk to attract a mate. Yet

We model the *imago Dei*—the fact that we are made in the image of God, the Creator and Celebrator.

it's not the same as the sort of dancing done by Fred Astaire, which is distinctly human. "No Strings (I'm Fancy Free)" has more than a Darwinian purpose (though it has that too). Compared to the birds, our dancing can be impulsive and uncalculated, performed for no other reason than the sheer joy of it. In this way we model the *imago Dei*—the fact that we are made in the image of God, the Creator and Celebrator.

Our joy has another fount, however. It is also one of the most instinctual ways we express thanks. Throughout the Bible, *joy* is used to describe a state of gratitude in which God is lauded for his creative prowess *and* his saving grace. And so

prayerful joy both looks back at what God has done at the dawn of time and looks forward to the end of human history, anticipating our full enjoyment of God in the new creation. It is historical and eschatological.

The book of Job is normally thought of as a tragic account, yet it also nicely captures the scope of joy, from the first creation to the new one. Notice, in God's cosmic challenge to Job, joy gets a mention: "Where were you when I laid the earth's foundation . . . while the morning stars sang together and all the angels shouted for joy?" (Job 38:4, 7). Creative, thankful prayers of joy were there right from the beginning, when all things were good.

Elsewhere in the book of Job, when one of Job's friends describes the jubilant gratitude of a sick man who has been healed, we get a hint of the role joy will play when God makes all things right:

> Then that person can pray to God and find favor with
> him,
> they will see God's face and shout for joy;
> he will restore them to full well-being.
> And they will go to others and say,
> "I have sinned, I have perverted what is right,
> but I did not get what I deserved.
> God has delivered me from going down to the pit,
> and I shall live to enjoy the light of life." (Job 33:26-28)

Likewise, in the Psalms joy is both an expression of thankfulness for salvation and a state for which the psalmist still longs: "Restore to me the joy of your salvation / and grant me a willing spirit, to sustain me" (Ps 51:12). In the vision of the new heaven and earth offered in Hebrews 12, heavenly figures once again

appear to gather with joy, as they did when God laid the earth's foundations: "But you have come to Mount Zion, to the city of the living God, the heavenly Jerusalem. You have come to thousands upon thousands of angels in joyful assembly" (Heb 12:22).

So our true joy is yet to come. What we express now is both thankfulness and anticipation. When I pray joyfully, I experience gratitude that becomes sustaining, that buttresses me when the joy fades and the longing returns.

We're waiting, then, waiting while made in God's image, waiting while redeemed by Christ and sustained by the Spirit, and waiting in anticipation of full restoration. What is one of the things we can do in the meantime? Offer prayers of joy, through our singing, our dancing, and our movies.

THE ART OF JOY

When it comes to cinematic joy, we must look to musicals first (a genre I was shamefully late to appreciate, having to get over my childhood aversion to a movie's narrative suddenly being interrupted by song). Sure, there are tragic movie musicals, such as Lars von Trier's *Dancer in the Dark*, in which Icelandic pop singer Björk plays a factory worker who is slowly going blind. Yet even that movie includes the moment in which Björk's Selma listens to the click and clack of the factory's machines and imagines herself in an elaborate, exuberant dance number with her coworkers. Similarly, *The Umbrellas of Cherbourg*, although the tale of young lovers separated by the Algerian War, has the sustaining cheer of its opening title sequence, in which an overhead shot captures a series of colorful and choreographed umbrellas as they pass below. (The pastel color scheme persists throughout the rest of the film in the production design, reminding us that some

semblance of joy remains, no matter what turns life takes.) Even *West Side Story*, so steeped in violence and ethnic tension, gives us the confident gaiety of "I Feel Pretty." The impulse of most movie musicals, then, is to sing—even in the rain.

This is because the human condition of joy is exactly as *Top Hat*'s Jerry Travers describes via his dancing: irrepressible. In *A Hard Day's Night*, you can hear it in the unceasing screams of the young women in the crowd at a Beatles concert or as they chase the band members down the street. In one sense *A Hard Day's Night* is a horror picture; there is a scene in which John, Paul, George, and Ringo conduct an impromptu jam session in the caged cargo section of a train, while adoring girls claw at them through the bars. Yet in another sense *A Hard Day's Night* is an expression of prayerful delight. When the Beatles perform, their creative joy merges with the audience's appreciative joy, becoming something rapturous and complete.

Although joy at the movies often involves music, it can take many other forms. One of the more irrepressible film characters of all time is Amélie (Audrey Tatou), a Parisian waitress who performs anonymous acts of kindness as liturgical gestures of joy. (*Amélie* director Jean-Pierre Jeunet matches her mood by using bold colors and impulsive edits, turning every frame into a delight.) In *Forrest Gump*, Tom Hanks's title character sees life itself as joyful opportunity—a box of chocolates, in fact. Going back further, you'll find joy in the swashbuckling of Errol Flynn (*The Adventures of Robin Hood, Captain Blood*) and Douglas Fairbanks Sr. (*The Mark of Zorro*). *His Girl Friday*, from 1940, runs on the joy of repartee, as Cary Grant and Rosalind Russell's sparring journalists banter at light speed with what can only be called effortless precision.

What all these movies have in common is a certain brightness, a certain sunniness, a certain anticipation. And when we experience those qualities, we want to rest in them. Discussing joy, happiness, and pleasure in his spiritual memoir *Surprised by Joy*, C. S. Lewis wrote that joy "has indeed one characteristic, and one only, in common with [happiness and pleasure]; the fact that anyone who has experienced it will want it again."[1] As such, joyful movies are immensely rewatchable, largely because they hint at a coming joy we've fleetingly felt and long to taste again. Lewis continued, "I doubt whether anyone who has tasted [joy] would ever, if both were in his power, exchange it for all the pleasures in the world. But then Joy is never in our power and pleasure often is."[2]

ALL ABOARD THE CATBUS

The two young sisters in *My Neighbor Totoro*, perhaps the greatest film from legendary Japanese animator Hayao Miyazaki, are certainly surprised by joy, especially by the form it takes. Having moved to a dilapidated country home with their father so they can be closer to their mother, who is ill in a nearby hospital, Satsuki and Mei push back against their family's sadness the way so many children do: with play. And so four-year-old Mei explores the nearby forest, where she stumbles across a ghostly rabbit-like animal. Chasing it into a dense, leafy lair, she encounters Totoro—a giant, fluffy, feline bear of sorts. The creature could devour Mei in one gulp, but he mostly prefers to nap.

As Totoro, Mei, and Satsuki become regular playmates, we wonder: Is Totoro an imaginary friend, a variation on the cotton-candied Bing Bong of Pixar's *Inside Out* (another film about the proper place of joy in a child's emotional landscape)? We're

never quite sure, and that's part of the movie's magic. One night, the girls plant acorns with Totoro and perform a ceremonial dance around them. Suddenly they sprout and quickly grow into an enormous tree. The next morning, however, the tree is gone, suggesting Mei and Satsuki imagined the whole thing. But then why are there new sprouts in the ground where they had danced?

Consider also the movie's most indelible sequence, in which Mei and Satsuki wait at a bus stop on a forest road for their father to come home from work. It's raining gently and getting dark, so dark that a streetlight eventually pops on, casting a golden glow on the road. The bus is late and Mei begins falling asleep, so Satsuki hoists her onto her back. After waiting some more, she hears squelching steps approaching and turns to see the enormous Totoro standing at the stop next to her, a giant frond on his head as protection from the rain. Satsuki hands Totoro her father's umbrella, and after taking a moment to figure out how to hold it, Totoro becomes delighted with the plopping sound the raindrops make when they hit it. The two enjoy their raindrop game for a bit—Totoro roars to make more drops fall from the leaves above them—when out of the darkness appears one of Miyazaki's most inspired creations: a catbus. Yes, a bus with the head, limbs, and tail of a cat. Totoro boards, and the catbus leaves.

This seemingly inconsequential interlude is, in fact, crucial in establishing the emotional texture of the film. Notice how Miyazaki and his animators employ shading to offset the sadness of Mei and Satsuki's lives with the joy that Totoro brings. That street lamp issues a small cone of light, illuminating the girls and part of the road, but beyond it, the forest is murky and the road disappears into the night. When Totoro arrives and stands next to Satsuki, half of his body is within the cone of light, while half

is in shadow. The umbrella Totoro holds catches the street lamp's glare and reflects it, bringing more brightness to the scene. As the raindrops do their delightful dance, Totoro's wide eyes and beaming smile literally shine. Totoro does what he does best: interrupts a moment of worry and fear with gentle good cheer.

It isn't only that Totoro cheers up these sisters. In serenely enjoying the rain together, in planting acorns that hold the potential for new growth, and in sitting among the branches of the resulting tree to observe the stars, Totoro teaches them how to cultivate prayerful joy in their own lives. Even in the midst of the emotional upheaval their family is experiencing, they experience and express deep-seated delight. I like to think that Totoro has shared with them a secret, a key to the universe: the knowledge that all can be endured, because one day their joy will be complete.

I like to think that Totoro has shared with them a secret, a key to the universe: the knowledge that all can be endured, because one day their joy will be complete.

HOLY NONSENSE

I'm of the generation that grew up on the Muppets, beginning with their 1976–1981 television variety show. What I've always loved about them, as both a child and now as a parent, is the way they steer clear of easy moralizing and sterile family values, yet are nevertheless imbued with a joy that is, at its very core, good. In their best films—*The Muppet Movie, The Great Muppet Caper,* and *The Muppets*—Kermit, Miss Piggy, Fozzie Bear, and the rest create what I consider to be holy nonsense.

Released in 2011, *The Muppets* resuscitated the franchise with the self-referential tale of a persistent fan who resurrects the Muppet show. Walter, a cheery Muppet who lives with his inexplicably human brother Gary (Jason Segel), travels to Hollywood, where he convinces Kermit to come out of retirement in order to save the Muppets' crumbling studio from falling into the hands of a nefarious developer. Instead of a morality play, what follows is mostly silliness: Animal going through anger management; Chris Cooper, as the evil developer, breaking into gangster rap; chickens doing a dance routine to a CeeLo Green song. Yes, occasionally and incidentally, a lesson is learned. As Walter tells Gonzo at one point, "When I was a kid and saw you recite *Hamlet* while jumping your motorbike through a flaming hoop, it, well, it made me feel like I could do anything."

There is a holiness to this nonsense, a sense in which it functions as prayerful joy. Christian joy, after all, is itself a response to the silly, the absurd: the *good news*. That God would come down to reclaim us through the sacrificial and atoning work of Jesus, rather than simply scrap it all and start over, is laughably illogical. Yet that's what he did, in what amounts to a cosmically nonsensical gesture. In his book *Telling the Truth*, Frederick Buechner places the gospel story within the literary traditions of tragedy, comedy, and fairy tale. Therein he describes "the comic truth of the Gospel, which is that it is into the depths of his absence that God makes himself present in such unlikely ways and to such unlikely people that old Sarah and Abraham and maybe when the time comes even Pilate and Job and Lear and Henry Ward Beecher and you and I laugh till the tears run down our cheeks."[3] That will be our joy, and it will be as silly and inexplicable as the holy nonsense embodied by the Muppets.

Elsewhere, Buechner captures another important quality of Christian joy: the way it unexpectedly disrupts the darkness (think Totoro at the bus stop). In *The Hungering Dark*, Buechner writes that "joy is a mystery because it can happen anywhere, anytime, even under the most unpromising circumstances, even in the midst of suffering, with tears in its eyes."[4] It seems fitting, then, that despite its frivolity, I'll always remember seeing *The Muppets* only a few hours after attending a wake for a friend's father. His was a particularly unexpected and senseless death. The two events of that day seemed almost insensitively at odds—how can the same day hold both a wake and the Muppets?—yet in another way the extreme juxtaposition of emotional experiences felt right. This world is a tragedy awash in inexplicable grief, yet God has responded in such a nonsensical, almost comical way that we can still know deep joy and anticipate even greater joy yet. Holy nonsense blows on the fading embers of our soul, bringing it back to glowing life. Or, as Walter puts it in *The Muppets*: "As long as there are singing frogs and joking bears, the world can't be such a bad place after all."

PASSAGE TO INDIA

The world is indeed a wonderful place for the newly married couple in 1959's *The World of Apu*, at least for a short time. This is the final film in what is known as writer-director Satyajit Ray's Apu trilogy, which follows a bright and curious boy from his childhood in rural India to his young adulthood in bustling Calcutta (and back again). Grief hovers over these films in palpable ways, as Apu witnesses the deaths of various family members over the course of his young life. But in *The World of Apu*, also

known as *Apur Sansar*, there is a long stretch of exquisite joy, as this young couple learns to enjoy each other.

Their romance, it should be noted, is not love at first sight. In fact, Apu (now a young man and played by Soumitra Chatterjee) and Aparna (Sharmila Tagore) find themselves in a hasty, unexpected, and mostly arranged marriage after her wedding to someone else falls through, and Apu is convinced to step in. The fact that Apu is barely scraping by as a tutor and Aparna's family is wealthy is only one of their obstacles, something Ray delicately captures in a tentative wedding night scene that takes place in an elaborately decorated bedroom. She stands still, expectant, on one side of the bed, while Apu paces back and forth on the other side, asking across a sea of expensive fabrics and beads: "Can you live with a poor husband?"

She can. After returning to Apu's modest apartment in Calcutta, the two eventually find themselves perfectly matched, something Ray reveals with a lovely montage of humble domestic bliss. Shy smiles evolve into loving gazes. A new curtain brings personality (and privacy) to their window. They linger in bed and over meals. There is a carnal joy to these scenes that recalls a prayer of that great Christian sensualist, Saint Augustine:

> But what do I love when I love my God? Not material beauty or beauty of a temporal order; not the brilliance of earthly light, so welcome to our eyes; not the sweet melody of harmony and song; not the fragrance of flowers, perfumes, and spices; not manna or honey; not limbs such as the body delights to embrace. It is not these that I love when I love my God. And yet, when I love him, it is true that I love a light of a certain kind, a voice, a perfume, a food, an embrace; but they are of the kind that I love in my

inner self, when my soul is bathed in light that is not bound by space; when it listens to sound that never dies away; when it breathes fragrance that is not borne away on the wind; when it tastes food that is never consumed by the eating; when it clings to an embrace from which it is not severed by fulfillment of desire. This is what I love when I love my God.[5]

Augustine's litany of pleasures—his referencing of temporal joys in order to capture a small sense of everlasting joy—is echoed in *The World of Apu*, where the couple's delight in each other also hints at something greater than earthly delectation. "Material beauty" and "earthly light" are captured by that pleasing curtain in the window, which filters the sun and flits in the breeze. When Apu plays the flute while watching Aparna go about her daily chores, he offers her "harmony and song"; he serves as her iPhone while she works to create a comfortable home. The scenes of the two eating together recall Augustine's "fragrance of flowers, perfumes, and spices," as well as his mention of "manna or honey." We first see Apu scooping food from his plate as Aparna sits on the floor across from him, gently fanning his plate to keep the flies away. Just as our twenty-first-century feminist hackles begin to rise, Ray cuts to a matching shot, in which Aparna eats while Apu fans for *her*. As for Augustine's reference to "limbs such as the body delights to embrace," *The World of Apu* is fairly chaste. Yet like the simmering romances of American movies from the 1920s to the 1940s, which were made under the censorious Production Code, the couple's desire is palpable. And, indeed, leads to a son.

The happiness of this marriage sequence would verge on fantasy if it wasn't offset both by the heaviness of the two Apu

movies that came before—*Pather Panchali* and *Aparajito*—and by the sorrow yet to come in *The World of Apu*. Taken as a whole (and even amid its references to Hindu tradition), the trilogy recalls the Christian concept of joy in the midst of suffering, of emphasizing celebration even in a sorrowful world.

"I'M IN HEAVEN . . ."

Back in her room, Ginger Rogers's Dale Tremont settles into bed, hoping that her chastising of Fred Astaire's Jerry Travers will have stopped the tap dancing from above. It has, though Jerry has replaced it with something softer and more soothing. By spreading the sand from a lobby cigarette bin on his floor and delicately sliding through it, he creates a footfall lullaby of sorts, and soon his delicate shuffling has Dale happily drifting off to sleep.

Thanks to a mistaken-identity plot that eventually kicks in, much more wooing remains in *Top Hat* before this pair finally unites. Jerry inches closer during one routine in which the hesitant Dale joins him amid other couples at the hotel dancing to Irving Berlin's "Cheek to Cheek." Things begin simply enough, as they demurely match the movements of the other couples in the room. Indeed, they would hardly stand out on the dance floor if it weren't for Jerry singing the words to the song:

Heaven, I'm in heaven
And my heart beats so that I can hardly speak
And I seem to find the happiness I seek
When we're out together dancing, cheek to cheek.

Smoothly, they slip out of the ballroom into an open courtyard where they're alone. And suddenly Jerry and Dale become Fred and Ginger. He sends her into delicate spins, so that the feathers

on her elaborate dress are freed to ripple through the air, as they were designed to do. She bends gracefully back onto his arm, a bit deeper and longer each time, as the routine transforms from a hesitant duet to a joyful one. The singing fades away, even as the words still echo in our ears: "Heaven . . . I'm in heaven."

Almost, Fred. Almost.

PRAYER AS JOURNEY

Have you noticed the timeline we've been tracing? As I mentioned in the first chapter, the types of prayer we've been considering have been arranged to follow a creation-fall-redemption-restoration trajectory: the understanding that this world was created good, fell into sin, has been redeemed by Christ's work on the cross, and now awaits the full return to its original glory. Christianity, after all, can be understood not only as

Christianity … can be understood not only as a religion but also as a story, one outlined by the framework of the Bible.

a religion but also as a story, one outlined by the framework of the Bible.

God uses story to communicate his very nature to us, as well as his plan for the world. We, in turn, use story to make

sense of our experience within his narrative. And so our prayers, including those uttered in the movies we watch, always fall somewhere along God's timeline. As this book has moved from praise to lament to confession to joy, the prayers we've considered have marked a progression, both of cosmic history and of individual experience. Each form of prayer delineates not only one epoch in time but also a moment of yours and a moment of mine.

We saw, at the start, how our prayers of praise are rooted in God's good creation. They express wonder at the glimmers of Eden we still witness, whether those are found in the teeming meadow of *Microcosmos* or in the creativity of the French New Wave. Then came the fall, which we respond to in a variety of ways: with a yearning to be reunited with God (*The Life Aquatic with Steve Zissou*), with lament over the broken state of creation (*12 Years a Slave*), and with anger over the realization that sin pervades both without and within (*Rebel Without a Cause*).

The turning point in the Christian story is the redemption that came with Christ's birth and death. And so prayers are offered in recognition of that: confessions of our inability to save ourselves (*Toy Story*); attempts at reconciliation, both with others and with God (*The Awful Truth*); pledges of obedience (*It's a Wonderful Life*); and contemplation of the immensity of what Jesus has accomplished (*The Straight Story*). And finally, our prayers of joy not only express delight over God's grace but also hint at the true joy we will experience in the restoration of the new heaven and the new earth (*Top Hat*; Rev 21).

An alignment of these prayers within God's cosmic story would look something like this:

- Creation: praise

- Fall: yearning, lament, anger

- Redemption: confession, reconciliation, obedience, meditation/contemplation

- Restoration: joy

We've looked at a vast array of films through the course of our journey from creation to restoration. Could there be one movie that encompasses this sojourn all on its own? Could a single film prayerfully envision the original glory of creation, mark the tragedy of the fall, evoke our redemption, and point ahead to the restoration that is to come?

I'll suggest *Rushmore.* In 1998, Wes Anderson released this modestly budgeted high-school comedy, his second feature. It's not a perfect film (as if such things exist), but it comes awfully close. The central figure is Max Fischer (Jason Schwartzman), a precocious fifteen-year-old who is so busy leading extra-curricular activities at the title prep school (French Club, Debate Team, Bombardment Society) that he's failing most of his classes. I was only a few years into my career as a film critic when the movie came out, and with my "professional," prove-it-to-me guard up, I only allowed myself to like, not love, the movie the first time I saw it. (Even getting the chance to interview Anderson and Schwartzman, who were touring the country in a canary-yellow bus on a press tour/publicity stunt, couldn't chip away at my prematurely hardened exterior.) Yet since then, *Rushmore* has become one of my personal favorites, as near to my heart as Max's school is to his. Even after more than a dozen viewings, its vision of adolescent ambition, disillusionment, and maturation strikes me as uncommonly knowing and fresh.

Max exalts Rushmore High School—to him it's heaven on earth—but in his pride and immaturity he's also something of a snake in his own garden. With a wit and precociousness all its own, *Rushmore* follows Max's spiritual journey from creation to restoration, a journey marked by each of the prayers we've explored. If you have yet to view *Rushmore* for the first time, I'd encourage you to set aside this book and give it a watch before continuing. Spoilers follow, yes, but mostly I want you to experience the movie the way I did: as a brazen burst of filmmaking ingenuity. Then we'll come back to consider how this comic story of one kid's tumultuous school year manages to echo the spiritual tumult we all experience, and the transformation for which we all long.

CREATION

Rushmore opens in September, at the start of a new school year. In a theatrical bit of production design, Anderson divides the film into sections by projecting the name of the month onto a curtain, which then opens to reveal the scene at hand. As these September days unfurl, they are full of possibilities, including those that only exist in Max's head. In fact, the first scene in the film is a dream sequence in which Max stuns his fellow students in math class by blithely solving an extra-credit problem that, according to his teacher, is "probably the hardest geometry equation in the world."

This is how Max sees Rushmore: as a fertile field for his own accomplishments. I can't say I ever dreamed of math glory, but I certainly identify with the aspirational impulse of these teen years. Yet whereas I remember eagerly awaiting graduation so that I could seriously pursue my (nonalgebraic) dreams, you get the sense Max never wants to leave. When Herman Blume, a school benefactor played by Bill Murray, raises an eyebrow at Max's unbridled

enthusiasm and asks him for the secret to his happiness, Max replies, "I think you've just got to find something you love to do and then do it for the rest of your life. For me it's going to Rushmore."

He isn't too far off. Outside of its main character's head, *Rushmore* offers prayerful praise for the gifts of learning, exploring, and cultivating, all good things that were given to us in Eden. Early on there is a brilliantly constructed montage set to the raw guitar chords of The Creation's "Making Time" that documents the many, many, many school clubs to which Max belongs. A three-second shot of Max arranging sports equipment includes this onscreen text: Lacrosse Team Manager. That's followed by a brief shot of him smashing a board with a kick and the denotation: Kung Fu Club Yellow Belt. And so on. In about sixty seconds, we get nineteen carefully framed tableaus that—strung together by those sixties rock strings—express the extent of Max's playground.

This one minute of movie is also a prayer of praise for the world as fertile garden. Only creative beings made in the image of a Creator would bother with a Calligraphy Club (of which Max is president). Even as it will go on to depict him as a petty and insufferable child, *Rushmore* has a fundamental admiration for Max, a belief in the root good of his pursuits and the creative being that he can be. After all, who wouldn't want to belong to the Rushmore Beekeepers?

FALL

There is something else being communicated in that montage, however: a palpable smugness on Max's part. Pride will be his undoing, just as it is for all of us. Notice the way Max is positioned within each frame of the montage. The first shot, marking Max as the publisher of the school's *Yankee Review*, shows him

walking toward the camera while giving emphatic instructions to the four boys with him, two on each side, all wearing light blue button-down shirts in contrast to Max's dark-blue sport coat. The following shots take similar care to make Max the central point of focus: placing him in the center-front desk of the twelve that make up the French Club, in the pattern of tic-tac-toe; having him stand apart from the others in the Astronomy Society as they gaze up at the sky while he stares into the camera. The defining shot in the montage is the one of him directing the school choir. Anderson sets up a mirror so we can see Max and the choir at the same time, while also revealing a matching image of his reflection. Max contains multitudes.

All of this captures the way Max sees himself within these groups. It's all about him. What is spiritual myopia, after all, other than the narrowing of the camera in our own lives until we only see ourselves in the frame (and moving in elegant slow motion)?

If such pride leads to the fall, Max's misguided understanding of his place within the world of Rushmore leads him to overstep his boundaries with a first-grade teacher named Miss Cross (Olivia Williams). After mistaking her politeness and amusement at his wunderkind spirit for romantic affection, Max goes so far as to invite her out to dinner, along with Bill Murray's Blume, after the premiere of his latest school play (an adaptation of the Al Pacino cop drama *Serpico*). When she brings along her own date (Luke Wilson), Max succumbs to the petty jealousy of a child. "I wrote a hit play!" he petulantly exclaims, marking one of the many moments in the movie when Max's reality collides with the real world.

Max isn't the only one suffering from disillusionment in *Rushmore*. In casting Bill Murray as Herman Blume, Anderson

chose an actor who drips disillusionment from every pore. There's something crucial to the fact that from the very first time we saw Murray as a young performer—in the early days of *Saturday Night Live*—his hair was already beginning to recede. In retrospect, it was an early sign of the deeply affecting, comically embittered dramatic performances that this improv comedian would go on to give. In films as varied as *Groundhog Day* and *Lost in Translation*, Murray plays men for whom life's promise has fizzled out. They find themselves stuck in places they never wanted to be, morosely and prayerfully yearning for something more.

My favorite scene in *Rushmore* documents just this sort of malaise. Murray's Herman Blume is the father of obnoxious, red-headed twin boys, and this is their birthday pool party as seen from their father's perspective. He watches alone from a chair on the far side of the backyard pool as his sons tear into their presents like spoiled brats, and his wife openly flirts with a younger man. (There's an insert shot of a Blume family portrait, which highlights the fact that his wife and sons have bright red hair, while his is a sad brown.) Back at the pool, Blume distractedly tosses golf balls into the water, as the loping guitar lines of The Kinks's "Nothin' in the World Can Stop Me Worryin' 'Bout That Girl" matches his melancholic mood.

Everyone at the party pauses to watch Blume at one point, so he decides to put on a show. Picking up his drink (whiskey, by the looks of it) and letting a forlorn cigarette hang from his mouth, Blume stumbles over to the high dive, bumbles his way to the top of it, and stands there: drink in hand, cigarette in mouth, beer belly hanging over Budweiser swim trunks. Anderson cuts to an overhead shot of Blume at the edge of the diving board—baldness on display, belly bulging, browned leaves floating in the murky

pool below—and then to a swerving POV shot as Blume takes in the party from his elevated, inebriated vantage point. Cut back to Blume, who walks to the back of the diving board for a running start, and then jumps. It's a cannonball as half-hearted suicide leap, a yearning, Hail-Mary prayer.

Sometimes we actively seek God; at other times we sink to the bottom of the pool, only half-hoping to be found. There is both stillness and terror down there. As with Jonah, the deep can be an escape and a death sentence at the same time. As Blume sits at the bottom of the pool, a scrawny kid in swim goggles comes floating by to see if he's okay. It's enough to motivate Blume to emerge from this particular belly of a whale and search for something more.

Such yearning prayer was the first type we considered as a response to the fall. The second was lament. For me, *Rushmore*'s figure of lament is Miss Cross. We eventually learn that her husband, Edward Appleby, died not long after they had married, and that earlier in his life he had been a student at Rushmore. And so she came to the school as a way to remember him. Or, as Max puts it to Blume after they become rivals for her attention, "She's in love with a dead guy anyway."

At one point in the film Max barges in on Miss Cross at home and discovers that she's actually living in Edward Appleby's childhood house and indeed sleeping in his bedroom, which is decorated with the model planes and wall posters of a young boy. When the conversation turns toward her deceased husband, she notes that he had more "spark, and character, and imagination in one fingernail" than her current paramours. Max replies, "One dead fingernail." Miss Cross stoically refuses to give an emotional response, save for one lone tear. Yet Max's barb stings.

Losing young husbands is not the way things were meant to be. Her somewhat perverse choice to live in Edward Appleby's bedroom is a lament of that irrefutable fact. It's both a memorial and a sorrowful prayer.

Max's intrusion on Miss Cross is one of his many attempts to upstage Blume in their increasingly outlandish rivalry. To capture the escalation of their antagonism, Anderson employs another amusing montage, one that functions as a comic prayer of anger. Max kicks things off by releasing a swarm of bees into the hotel room Blume has moved into, having been kicked out of his house by his wife. When Blume notices a tube poking beneath the hotel door, from which the bees are emerging, he smiles in admiration at Max's audacity. And then the smile slowly curls into a sneer, as the wheels of revenge begin turning in Blume's mind.

The music for this montage comes from a section of The Who's "A Quick One While He's Away," which itself ratchets up from an a cappella chorus to the frenzied, repeated phrase: "You are forgiven!" Blume responds to the bee stunt by screeching up to Max's new public high school. (Max has been expelled from Rushmore at this point, in effect kicked out of the Garden of Eden). Taking Max's bike from the rack out front, Blume drives over its front tire with his car. Max in turn sneaks into Blume's factory and cuts his car's brakes, which nearly kills Blume when he arrives to pick up his sons from Rushmore but can't stop the vehicle. Things have gone too far, and this last prank lands Max in jail, where he is bailed out by his patient, long-suffering father (Seymour Cassel) as Pete Townshend's ironic cry of "forgiven" fades from our ears. The prospect of forgiveness, indeed, often seems like a pipe dream. Sometimes, beset by life's disappointments and betrayals, praying in anger is all we can muster.

REDEMPTION

A sort of redemption eventually comes to *Rushmore*, via an unlikely figure: Dirk Calloway, Max's younger, squeaky-voiced chapel partner. Dirk, played by Mason Gamble, has a child's indignant sense of what is right. He still believes that fairness, not fallenness, is standard operating procedure. At first Dirk applies this worldview in defense of Max. (He's the one who informs Max—in a crayon-written note—about Blume and Miss Cross's increasing closeness.) Yet later in the film the tables turn, after Max, in an ill-advised bid to impress a school rival, starts a crass rumor about Dirk's mother. This causes a rift between them, punctuated by a comic scene in which Dirk leads a Halloween-costumed band of pip-squeaks in an ambush of Max in the Rushmore courtyard.

Dirk, however, cannot wallow in anger; his youthful openness moves him to offer a prayer of confession. After some time passes, during which Max, Blume, and Miss Cross all go their separate ways, Dirk visits Max at his father's barbershop, where Max now works rather than attend school. He apologizes for the ambush and then, rather than demand an apology in return, he gives Max a Christmas present—a Swiss army watch, with a personal inscription:

<div align="center">

Max Fischer

RUSHMORE YANKEE

1985–1997

</div>

It's a quiet moment, underplayed. Notably, Max's response doesn't come until later, in an equally understated way. In a subsequent scene, he and Dirk are flying a yellow kite while standing forlornly on a vast parking lot. The sky is chilled gray. There are

sad puddles on the ground. After a moment of silence, Max finally apologizes for the lie he told about Dirk's mother. Dirk accepts, and reiterates his apology for the Halloween ambush. On cue, we hear the whine of a remote-control plane, which loops around their kite before commandingly landing at their feet. It's flown by Margaret Yang (Sara Tanaka), a former public-school classmate of Max's who has an unrequited crush on him. She's something of a kindred spirit to Max (she has a hand-written flight plan for her plane), yet he's repeatedly ignored or dismissed her. "You're a real jerk to me, you know that?" she says, before sending her plane into a perfect takeoff as an exclamation point. Max offers yet another apology, this time to Margaret. No eyes have been closed or hands folded, yet there have been three prayers of confession in this scene.

After Margaret leaves, Max takes over flying the kite and offers a gesture of reconciliation that is very Max Fischer-like, yet also something new for him. After a burden-releasing sigh, he asks Dirk to take dictation and begins suggesting "possible candidates for a kite-flying society." As the list goes on (Dirk and Margaret's names are on it), Max gives a flashy zigzag tug to the kite's string. And with that lovely little physical bit of acting by Schwartzman (aided by another perfect soundtrack choice, Cat Stevens's "The Wind"), we understand: Max's ambition and enthusiasm have returned, yet this time with an added humility and appreciation for community. If a kite needs only gentle tugging to fly, if the real work is done by the wind, so will Max's endeavors from here on out have a newly found combination of ambitious vision, corporate participation, and willingness to cede control. In confessing his shortcomings and seeking reconciliation, Max has been freed from his greatest burden: his prideful, misguided idea

of himself at the center of the Rushmore universe.

In Anderson's movies these instances of redemption sneak up on you, ever so faintly, as the characters experience unexpected epiphanies. I think of these as sunrise scenes, beautifully rendered fleeting moments in which a new way of living dawns on the screen. It's worth noting that these interior discoveries are freely, mysteriously given—gifts of grace—rather than rewards the characters have earned. Redemption works for us, after all, in the same way.

There is a sunrise scene, a corollary to Max's yellow kite, in almost every one of Anderson's films. The confrontation with the jaguar shark in *The Life Aquatic with Steve Zissou*, which we considered as a yearning prayer, is another. For reasons I've never quite been able to fully grasp, I find these epiphanies to be deeply moving (like Miss Cross, I usually let loose a tear). There is something precious and delicate to the manner in which a new way of seeing suddenly occurs to these characters, leaving them both enlightened and bewildered. I suppose it's a powerful thing to witness the receiving of grace.

It's a powerful thing to witness the receiving of grace.

What is Max's response to his redemption? In addition to his confession and pursuit of reconciliation, Max also offers a prayer of obedience. This means returning to Grover Cleveland, the public high school he had been attending, and finding a way to flourish within its rules. Once resettled there, he stages another

play, this time with an emphasis on building community among the cast and crew. If Max's earlier rendition of *Serpico* involved him getting punched in the nose for berating one of his actors, the new play (a Vietnam War drama meant to honor Blume, who fought in that conflict) includes roles that have been given as peace offerings: to Margaret Yang, for one, and to Magnus Buchan (Stephen McCole), the Rushmore bully who had been one of Max's adversaries. Tellingly, the curtain conceit Anderson had been using to divide his film into chapters returns here, revealing that Max's play debuts in that month of resolutions and new chances: January.

The play is ambitious, with smoke effects and explosions, but also clumsy and earnest in a way that reminds us that Max is still a naive teenager. (Its title? *Heaven and Hell.*) Yet despite its juvenile nature, the production moves people. Blume in particular is transfixed. During the opening battle scene, as everyone else dons the safety glasses and ear plugs that have been provided, Blume sits in a reverie, unbothered by all the pyrotechnics and completely absorbed by the world that has been re-created on stage. At intermission there is a shot of him outside of the auditorium deep in thought as he stares out at the rain. Asked what he thinks of "Max's latest opus," he offers a thumbs-up sign. "It's good," he says in a daze, "but let's hope it's got a happy ending."

The final scene in the play, in which Max's American grunt and Margaret Yang's Vietcong soldier impulsively decide to marry, reduces Blume to tears. The audience gives the play a standing ovation, and Blume rises in silence, his fist raised in solidarity. Whether nostalgia has overcome him or he's experienced his own epiphany, we never quite know. Blume's deeply personal experience—like any good prayer of meditation and contemplation—remains mysteriously his own. If the opening of a flower or the rising of bread dough

can be pathways to contemplative prayer, why can't a high-school play about the Vietnam War be the same for Herman Blume?

RESTORATION

While most movies are fond of redemption stories, few imagine what the world will look like when things are returned to the way they were meant to be. *Rushmore* is rare in that it goes beyond Blume's idea of a "happy ending" to offer a vision of restoration. Here, it looks like the *Heaven and Hell* after party held in the Grover Cleveland gymnasium.

For starters, almost everyone is there—even minor characters such as Rushmore's groundskeeper (Kumar Pallana) and the bewildered date (Luke Wilson) Miss Cross had brought to *Serpico*. As they gather for punch and snacks, Anderson moves the camera among them with a series of unbroken takes, floating from one conversation to the next. The emphasis is on their togetherness, the fact that these people are all in community, in the same space.

Notice especially the way Max introduces his guests to each other. Miss Cross is "my friend," no longer his object of misguided romantic affection. Blume, similarly, is described as a friend, not a rival. The most significant introduction may be the one Max gives for his father (Seymour Cassel). Having previously misled people to believe that his father was a neurosurgeon (therefore too busy to come to his plays), Max this time has not only invited him but also proudly introduces him this way: "I'd like you to meet my father, Bert Fischer. He's a barber." Prideful lies have been set aside, and relationships are put in their proper order.

In this miniature new creation that is *Rushmore*'s final scene, the characters exude both a peaceful camaraderie and a deep joy. And they express this prayer of joy in the tradition of Fred Astaire

and Ginger Rogers: by dancing. Max's math teacher asks his father to dance. Miss Cross extends an invitation to Max. He looks over at the DJ and asks if he can play something "a little more . . ."

We lose Max's words there and instead we hear the beginning of the Faces's "Ooh La La." There is a cut to a wider shot of the gym, encompassing everyone in the scene, and then the camera slowly pulls back further as the music draws more people to the dance floor. Almost imperceptibly, everyone's dancing begins to decelerate, until we realize that the scene has shifted into slow motion, lending a goofy elegance to their movements. (There is something heavenly about the sight of a sixty-something Seymour Cassel swinging in slow motion.) Time itself has taken on new con

The curtain closes, and *Rushmore*'s prayer concludes. Yet in my mind, they're all still dancing.

tours. We're in a place as mundane as a high-school gym that nonetheless feels extraordinarily of another world. The curtain closes, and *Rushmore*'s prayer concludes. Yet in my mind, they're all still dancing.

MY PRAYER

How, then, should we pray? What has this book-length exercise in cultural refraction—a consideration of various films through the prism of prayer and the overarching story of Scripture—revealed?

I hope a few things: that movies, at their most potent, are not diversions or products or even works of art, but prayerful gestures received by God; that we best honor movies when we allow

them this potential, rather than treat them like ways to pass the time or purchases to be made or unwashed items to be dissected according to an arbitrary moral code; and that no matter what our response, God still watches them with a heart that is both righteous and merciful.

As we watch films, then, let's enter the theater as we would a sanctuary where a prayer is about to be offered. Let's listen to the prayer carefully and graciously before we add our own words. Let's be a congregation, not a censor board. Let's be open to the possibility that as movie watchers, we're privileged eavesdroppers on a dialogue between God and the creative beings he made.

And let's offer our own prayer:

Dear God,

We pray for your presence in our theaters, in our homes, and wherever we participate in one of your great gifts: the art of cinema. Receive the praise of Avatar. *Answer the yearning of* The Life Aquatic with Steve Zissou. *Hear the lament of* 12 Years a Slave. *Be merciful in the face of James Dean's anger. Accept Buzz Lightyear's confession. Bless the tentative reconciliation of* Do the Right Thing. *Encourage George Bailey as he obeys. Meet Buster Keaton in meditation. Stoke Fred and Ginger's joy. Thank you for the movies, Lord, and the talents you've given to those who make them. We ask for your guidance, so that we may watch and pray with a wisdom and grace that honors you.*

Fin/Amen.

ACKNOWLEDGMENTS

First—and I know I sound like an athlete being interviewed after the big game here, but the truth is athletes often have a confidence in their faith that I lack—I'd like to thank God. I don't know why he led this project to be a part of my life, but it has been a creative blessing and a fruitful spiritual practice, allowing me to better appreciate how he moves in my life.

One of the ways he moves, of course, is through other people. And so I want to thank Debbie, my wife. It turns out writing a book is like bringing a boarder into your home, one who stays up late, gets up early, and makes your husband watch way too many movies with him. Thank you for encouraging me to take on this intrusion and for being supportive throughout. And thanks to my daughters, Adeline and Beatrix, for also putting up with my busyness. I hope that was somewhat offset by the time we spent watching some wonderful movies together: *The World of Apu* with Bea; *Rushmore* with Addie; *The Straight Story, Top Hat*—we watched a lot.

I also want to thank my dad, Dave Larsen, and my pastor, Roger Nelson, for reading drafts of early chapters and getting me off on the right foot. I've been blessed throughout my life by Christian mentors and family members who never looked askance at my intense movie habit—including my late mother, Cathy, who lived just long enough to learn that this project was actually going to happen.

There are two people at InterVarsity Press in particular who made that a reality: Ethan McCarthy, who first brought me to the company's attention and who saw the book through its final editing stages, and Helen Lee. As editor, Helen ably guided me, a first-time author, through the proposal process, the writing itself, and the crucial revisions, even hanging around at the end while she moved into her new role as director of marketing at IVP. Helen's fruitful ideas, gentle prodding, and overall guidance were invaluable. It's truly a shame that good editors aren't given more public credit for their work on a book.

To that end, it was eye-opening to realize how many people behind the scenes are crucial in getting a book published. My name alone on the cover is misleading, to say the least. To anyone at IVP who touched this project in any way, thank you. Every step of the process, I felt as if the work was in good hands.

Thanks also to Adam Kempenaar, Sam Van Hallgren, and all the other folks who make *Filmspotting* such a vibrant place for movie conversation. I told Adam after my first-ever guest appearance that being on the show forced me to hone my critical skills, and that's still true every week. Furthermore, I know that IVP had confidence in this project in large part because of *Filmspotting* as a platform. I'll always be grateful for that.

Speaking of platforms, *Think Christian*—where my day job is as editor and critic—was a laboratory of sorts for so much of this

book. I had the basic idea before joining ReFrame Media, *Think Christian*'s parent ministry, but I wasn't ready to write it until I had spent a few years working and learning alongside the bright, talented, devoted people there. Steven Koster, Robin Basselin, and the rest of the team got behind the book from day one, allowing me the flexibility to fit screenings and research into my schedule and even giving me a few days near the end to bring things in under the wire. It took me a while to find my place in the Christian media landscape. ReFrame is it.

Last, I want to thank the friends, colleagues, and other supporters who don't identify as Christian, yet who encouraged this project, whether by offering comments on social media or endorsements of the finished product. As a child of the culture wars that dominated the American landscape in the 1980s and 1990s, I never would have predicted the graciousness with which this sort of Christian film criticism has been received.

NOTES

CHAPTER 1: MOVIES ARE PRAYERS?

[1]Theophan the Recluse, quoted in *Philokalia: The Eastern Christian Spiritual Texts*, trans. G. E. H. Palmer, Philp Sherrard, and Kallistos Ware; annotated by Allyne Smith (Woodstock, VT: Skylight Paths, 2006), 32.

[2]Richard Foster, *Prayer: Finding the Heart's True Home* (San Francisco: HarperSanFrancisco, 1992), xi.

[3]"Our World Belongs to God," *Christian Reformed Church*, n.d., www.crcna .org/welcome/beliefs/contemporary-testimony/our-world-belongs-god.

[4]Abraham Kuyper, *Wisdom & Wonder: Common Grace in Science & Art* (Grand Rapids: Christian's Library Press, 2011).

[5]James D. Bratt, ed., *Abraham Kuyper: A Centennial Reader* (Grand Rapids: Eerdmans, 1998), 461.

[6]Kuyper, *Wisdom & Wonder*, 160.

[7]Christian Wiman, *My Bright Abyss: Meditation of a Modern Believer* (New York: Farrar, Straus and Giroux, 2013), 130.

[8]Alissa Wilkinson, "Why We Review R-Rated Films," *Christianity Today*, January 24, 2014, www.christianitytoday.com/ct/2014/january-web-only /why-we-review-r-rated-films.html.

[9]Foster, *Prayer*, 8.

CHAPTER 2: MOVIES AS PRAYERS OF PRAISE

[1]Anne Lamott, *Help, Thanks, Wow: The Three Essential Prayers* (New York: Riverhead Books, 2012), 83.

[2]Walter Brueggemann, *Israel's Praise: Doxology Against Idolatry and Ideology* (Philadelphia: Fortress Press, 1988), 1.

[3]Ibid., 2.

[4]Andy Crouch, *Culture Making* (Downers Grove, IL: InterVarsity Press, 2008), 23.

[5]Ibid., 31.

[6]Saint Ignatius, *The Spiritual Exercises of Saint Ignatius of Loyola* (Mineola, NY: Dover Publications, 2011), 21.

[7]Charles Spurgeon, "Prayer Perfumed with Praise," *The Spurgeon Archive*, April 20, 1879, www.spurgeon.org/sermons/1469.php.

[8]William Williams, "Guide Me, O Thou Great Jehovah," 1745. This song is also known as "Bread of Heaven."

CHAPTER 3: MOVIES AS PRAYERS OF YEARNING

[1]Eugene H. Peterson, *Answering God: The Psalms as Tools for Prayer* (San Francisco: Harper & Row, 1989), 4.

[2]Christian Wiman, *My Bright Abyss: Meditation of a Modern Believer* (New York: Farrar, Straus and Giroux, 2013), 76.

[3]Henri J. M. Nouwen, *The Return of the Prodigal Son: A Story of Homecoming* (New York: Doubleday, 1992), 5.

CHAPTER 4: MOVIES AS PRAYERS OF LAMENT

[1]W. E. B. Du Bois, *The Souls of Black Folk* (Chicago: A. C. McClurg, 1907), 253.

[2]Nicholas Wolterstorff, *Lament for a Son* (Grand Rapids: Eerdmans, 1987), 52.

[3]Claus Westermann, *The Psalms: Structure, Content, and Message* (Minneapolis: Augsburg Fortress, 1980), 55.

[4]John D. Witvliet, "A Time to Weep: Liturgical Lament in Times of Crisis," *Reformed Worship*, June 1997, www.reformedworship.org/article/june-1997/time-weep-liturgical-lament-times-crisis.

[5]Barbara Brown Taylor, *Learning to Walk in the Dark* (New York: HarperOne, 2014), 48.

[6]Wolterstorff, *Lament for a Son*, 69.

[7]Ibid., 70-71.

[8]Du Bois, *Souls of Black Folk*, 261.

CHAPTER 5: MOVIES AS PRAYERS OF ANGER

[1]John Piper, "Is It Ever Right to Be Angry at God?" *Desiring God*, October 16, 2002, www.desiringgod.org/articles/is-it-ever-right-to-be-angry-at-god.

[2]Christian Wiman, *My Bright Abyss: Meditation of a Modern Believer* (New York: Farrar, Straus and Giroux, 2013), 53.

[3]Walter Wangerin Jr., *Whole Prayer* (Grand Rapids: Zondervan, 1998), 82.

CHAPTER 6: MOVIES AS PRAYERS OF CONFESSION

[1]Calvin Miller, *The Path of Celtic Prayer* (Downers Grove, IL: InterVarsity Press, 2007), 137.

[2]Kenneth Leech, *True Prayer: An Invitation to Christian Spirituality* (San Francisco: Harper & Row, 1980), 135.

[3]Miller, *Path of Celtic Prayer*, 155.

[4]Leech, *True Prayer*, 129.

[5]Richard J. Foster, *Prayer: Finding the Heart's True Home* (San Francisco: HarperSanFrancisco, 1992), 14.

CHAPTER 7: MOVIES AS PRAYERS OF RECONCILIATION

[1]Emmanuel Katongole and Chris Rice, *Reconciling All Things: A Christian Vision for Justice, Peace and Healing* (Downers Grove, IL: InterVarsity Press, 2008), 18.

CHAPTER 8: MOVIES AS PRAYERS OF OBEDIENCE

[1]David Edelstein, "Now Playing at Your Local Multiplex: Torture Porn," *New York*, January 2006, www.nymag.com/movies/features/15622/.

[2]John Milton, *Paradise Lost* (New York: Modern Library, 2008), 24.

[3]Heidelberg Catechism pt. 3, q. 86, *Christian Reformed Church*, www.crcna .org/welcome/beliefs/confessions/heidelberg-catechism.

[4]Roger Olson, "The Bonds of Freedom," *Christianity Today*, October 5, 2012, www.christianitytoday.com/ct/2012/october/bonds-of-freedom.html.

CHAPTER 9: MOVIES AS PRAYERS OF MEDITATION AND CONTEMPLATION

[1]Suzanne Deason and Rod Stryker, *5 Day Fit Yoga*, dir. Steve Adams, Gaiam Americas, 2009.

[2]Philip F. Reinders, *Seeking God's Face: Praying with the Bible through the Year* (Grand Rapids: FaithAlive Resources, 2012).

[3]Margaret Silf, *Close to the Heart: A Guide to Personal Prayer* (Chicago: Loyola Press, 1999), 132.

[4]William Wordsworth, "Tintern Abbey," *William Wordsworth: The Major Works* (New York: Oxford University Press, 1984), 132.

[5]John of the Cross, *Ascent of Mount Carmel* (New York: Cosimo Classics, 1906), 125.

[6]Thomas Merton, *Contemplative Prayer* (New York: Image Books, 1996), xxxi.

[7]Julian of Norwich, quoted in Brendan Doyle, *Meditations with Julian of Norwich* (Santa Fe, NM: Bear, 1983), 59.

[8]Merton, *Contemplative Prayer*, 67.

[9]Teresa of Ávila, *The Way of Perfection* (Mineola, NY: Dover Publications, 1946), 198.

[10]Ibid., 200.

[11]Julian of Norwich, quoted in Doyle, *Meditations with Julian of Norwich*, 48.

[12]Silf, *Close to the Heart*, 174.

CHAPTER 10: MOVIES AS PRAYERS OF JOY

[1]C. S. Lewis, *Surprised by Joy* (New York: Harcourt Books, 1955), 18.

[2]Ibid.

[3]Frederick Buechner, *Telling the Truth* (San Francisco: HarperSanFrancisco, 1977), 98.

[4]Frederick Buechner, *The Hungering Dark* (New York: Seabury Press, 1981), 102.

[5]Augustine, *Confessions* (London: Penguin Books, 1961), 211.

INDEX OF MOVIE TITLES

INDEX OF MOVIES BY TYPE OF PRAYER

Praise

Avatar

Babette's Feast

Breathless

Children of Men

Cleopatra

Fantastic Voyage

How Green Was My Valley

Into the Wild

Jiro Dreams of Sushi

Microcosmos

This Is the End

The Tree of Life

Yearning

2001: A Space Odyssey

Casablanca

Close Encounters of the Third Kind

Contact

The Fountain

Hiroshima Mon Amour

Interstellar

In the Mood for Love
Last Year at Marienbad
The Life Aquatic with Steve Zissou
The Matrix
The Seventh Seal
Solaris
A Trip to the Moon
The Wizard of Oz

Lament
12 Years a Slave
Amour
Away From Her
Chinatown
The Dark Knight
Godzilla (1954)
Inside Llewyn Davis
Miller's Crossing
No Country for Old Men
Requiem for a Dream
The Sacrifice
A Serious Man
Watchmen

Anger
The Big Sleep
Fight Club
Freaks
Irréversible
King Kong (1933)
The Maltese Falcon
The Piano
Rebel Without a Cause
Requiem for a Dream

Hostel
It's a Wonderful Life
A Man Escaped
March of the Penguins
A Nightmare on Elm Street
Night of the Living Dead
Pinocchio
Psycho
Rocky
Saw
The Silence of the Lambs
Star Wars saga
Sunrise

Meditation/Contemplation

Bambi
The Blair Witch Project
The Decalogue
Diary of a Country Priest
The Last Temptation of Christ
Leviathan
The Master
Once Upon a Time in Anatolia
Ordet
Rififi
Sherlock, Jr.
Steamboat Bill, Jr.
The Straight Story
Upstream Color

Joy

The Adventures of Robin Hood
Amélie
Aparajito

Captain Blood
Dancer in the Dark
Forrest Gump
The Great Muppet Caper
A Hard Day's Night
His Girl Friday
Inside Out
The Mark of Zorro
The Muppet Movie
The Muppets
My Neighbor Totoro
Pather Panchali
Top Hat
Umbrellas of Cherbourg
West Side Story
The World of Apu

ABOUT THE AUTHOR

Josh Larsen is co-host of the radio show and podcast *Filmspotting*, as well as an editor and film critic at *Think Christian*, a faith and culture website. He's been writing and speaking about movies professionally for more than two decades.

Josh's career began in the mainstream newspaper business, where he started out as a beat reporter for a weekly community newspaper and went on to become the film critic for a daily, Chicago-area paper. In 2011, he joined the Christian media landscape as editor of *Think Christian*, a project of ReFrame Media that helps culturally engaged believers reflect faithfully on art, science, business, politics, and more. Josh joined the long-running *Filmspotting* podcast in 2012. Produced weekly and aired on WBEZ in Chicago, the show features reviews, interviews, and Top 5 lists, and was launched in the early days of iTunes in 2005.

A veteran of the Sundance, Toronto, and Chicago International Film Festivals, Josh has given talks on film and faith at various Christian colleges. He also led the "Ebert Interruptus," a tradition established by Roger Ebert that analyzes a single film scene by scene over several days, at the University of Colorado's Conference on World Affairs.

Josh lives in the Chicago area with his wife and two daughters. Visit larsenonfilm.com for his latest work, as well as an archive of almost every review he's ever written. You can connect with him on Facebook, Twitter, and Letterboxd via larsenonfilm.com.